IN & AROUND POCKLINGTON
THROUGH TIME
Paul Chrystal

AMBERLEY PUBLISHING

Acknowledgements

Thanks to Andrew Sefton and the Pocklington & District Local History Group for kindly allowing me to use so many of his cards and photographs; without them this book would not exist. Thanks also to Jane Cook of The Rocking Horse Shop, Fangfoss, for permission to photograph her wonderful shop, and to Angie Edwards, Librarian and Archivist at Pocklington School, for permission to use the old pictures of the school and to take the new ones. All of the modern photography is by the author. The Terry's picture on page 21 is provided courtesy of the Borthwick Institute for Archives, University of Yorkshire.

Paul Chrystal and Mark Sunderland are authors of the following titles in the *Through Time* series published in 2010: *Knaresborough; North York Moors; Tadcaster; Villages Around York; Richmond & Swaledale; Northallerton.*

Paul Chrystal and Simon Crossley are authors of the following titles in the series, published or to be published in 2011: *Hartlepool; In & Around York; Harrogate; York Places of Learning; Redcar, Marske & Saltburn; York Industries; Vale of York; Barnard Castle & Teesdale.*

Other books by Paul Chrystal: *A Children's History of Harrogate & Knaresborough, 2011; A to Z of Knaresborough History Revised Edn, 2011; Chocolate: The British Chocolate Industry, 2011; York and Its Confectionery Industry, 2011; Confectionery in Yorkshire – An Illustrated History, 2011; Cadbury & Fry – An Illustrated History, 2011; The Rowntree Family and York, 2012; A to Z of York History, 2012.*

To see more of Simon Crossley's work please go to *www.iconsoncanvas.com.* To see Mark Sunderland's work visit *www.marksunderland.com.* For the Rocking Horse Shop see *www.rockinghorse.co.uk*; the Pocklington & District Local History Group is at *www.pocklingtonhistory.com.*

First published 2012

Amberley Publishing
The Hill, Stroud
Gloucestershire, GL5 4EP

www.amberley-books.com

Copyright © Paul Chrystal, 2012

The right of Paul Chrystal to be identified as the Author of this work has been asserted in accordance with the Copyrights, Designs and Patents Act 1988.

ISBN 978 1 4456 0745 0

British Library Cataloguing in Publication Data. A catalogue record for this book is available from the British Library.

Typeset in 9.5pt on 12pt Celeste.
Typesetting by Amberley Publishing.
Printed in the UK.

Introduction

The area of Yorkshire east of York oddly tends not to enjoy quite the same fame as the Yorkshire Dales and the North York Moors. Oddly, because the Derwent Valley and the Wolds offer quite spectacular, unique and unspoilt scenery in a land of superlatives, which has been crucial to the course of British history, and home to a number of the nation's leading politicians and industrialists.

First the superlatives: at 7 feet 9 inches, William Bradley of Market Weighton is England's tallest-ever man; the Kiplincotes Derby is Britain's oldest flat race; in the same vein, the world's largest rocking horse was carved in Fangfoss in 2011; the first Victoria Cross of the Second World War was awarded to Pocklington School old boy 2nd-Lt Richard Annand; and David Hockney's *Bigger Trees Near Warter* is his biggest-ever painting.

Now the history: Pocklington was the site of King Edwin's assembly in 627, the destruction of the pagan temple at Goodmanham and the establishment of Christianity in northern Britain; the precursor to the Battle of Hastings took place at Stamford Bridge – we can only speculate on what may have happened if Harold's troops had not been wearied by their victory here and the subsequent march south.

And the people? Joseph Terry was born in Pocklington and went on to found one of the world's most successful chocolate companies in York; Thomas Cooke was born in Allerthorpe and went on to build the world's finest (and largest) telescopes with York company Cooke, Troughton & Simms; William Wilberforce, a Pocklington School old boy, was, of course, one of the main driving forces behind the abolition of slavery.

Add to this the beautiful Vatican-inspired church at Bishop Wilton, the witches Old Wife Green and Peg Fyfe, and the latter-day, and just as hubristic, 'Icarus', Thomas Pelling, and *In & Around Pocklington* has a fascinating story to tell.

Paul Chrystal

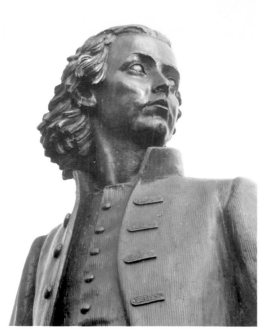

Famous Faces
A young William Wilberforce outside his old school, and a statuesque William Bradley standing sentinel in his hometown of Market Weighton.

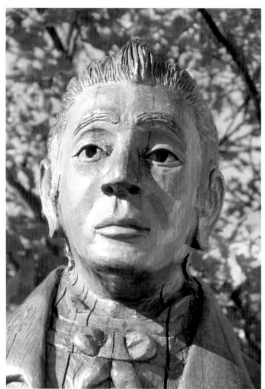

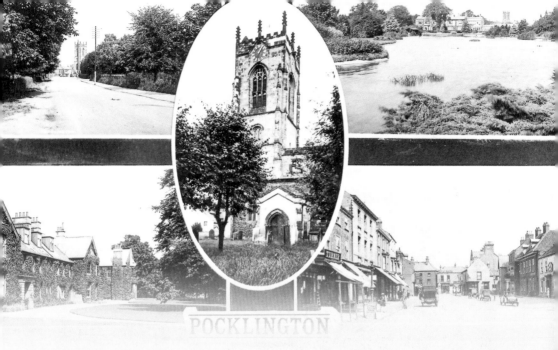

CHAPTER 1

'Woldopolis'

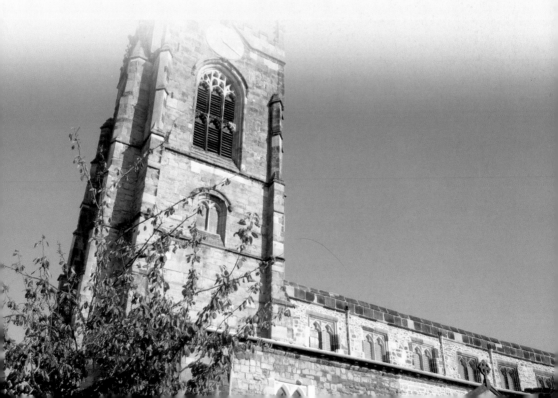

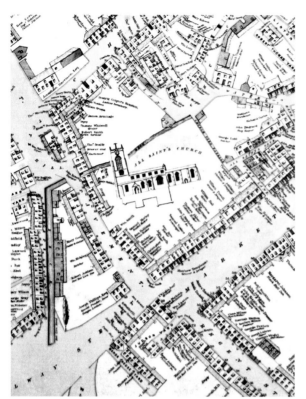

William Watson's Maps and the Flying Man

A detail from William Watson's 1855 map of Pocklington focussed on All Saints' Church and Market Place.

All Saints' was where Thomas Pelling, an acrobat popularly known as the 'Flying Man', 'was killed by jumping against the Battlement of ye Choir when coming down ye rope from ye steeple' in April 1733. Trying to outdo Icarus, no doubt, with his homemade bat wings, the rope he used to sling between one of the steeple pinnacles and the Star Inn, and to which his ankle was attached by a pulley, slackened, with fatal consequences; he is buried in the graveyard precisely where he fell. The annual Flying Man Festival celebrates the event and includes activities such as abseiling down the steeple. The modern picture shows Simply Books, Pocklington's book and map sellers.

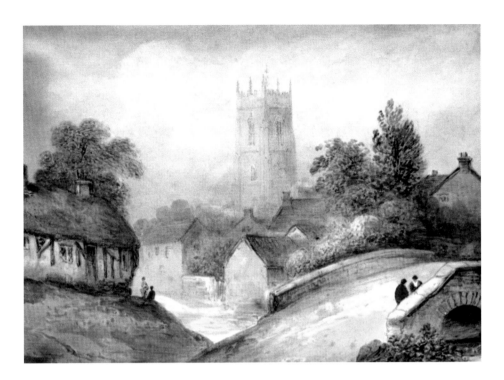

Beast Fair Bridge

Early nineteenth-century Pocklington, captured in this painting by local artist J. Kelsey. The Kelseys were wheelwrights in West Green near where this scene was painted. The stone bridge has been superseded by the mini roundabout outside today's library and the beck has been culverted. Hiring fairs and cattle markets were held in the vicinity. Pocklington was called 'Woldopolis' in newspaper articles around 1900 to denote its position as the commercial capital of the region.

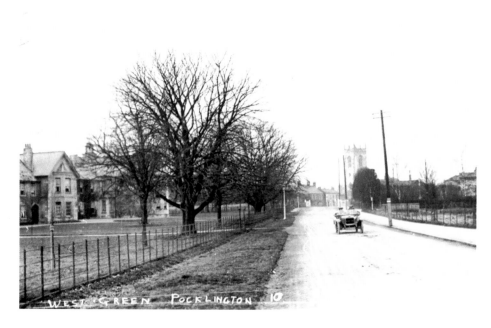

West Green in the English Civil War

A lone motor car proceeds out of town, with Pocklington School on the left and All Saints' Church dominating the background. Town fairs were held here, as was the annual horse race and games of cricket and rugby. West Green swapped sides during the Civil War when the Royalists camped here in 1643 and then the Parliamentarians in 1644. Musket balls from the time have been excavated.

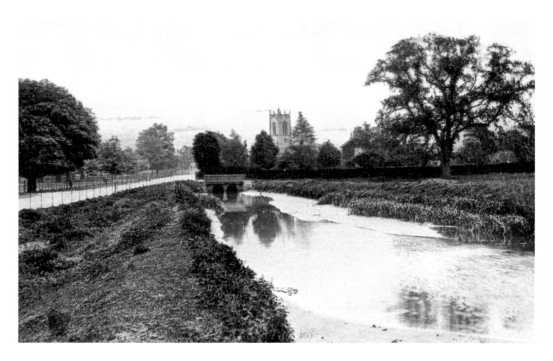

West Green and the Pocklington Militia

In the early nineteenth century, when England was preparing to repel a possible Napoleonic invasion, West Green was also the parade ground for the Pocklington Militia. Archaeological finds here include Neolithic flints, Iron Age skeletons, Bronze Age axes, Roman coins and paraphernalia from the medieval fairs, including lead weights.

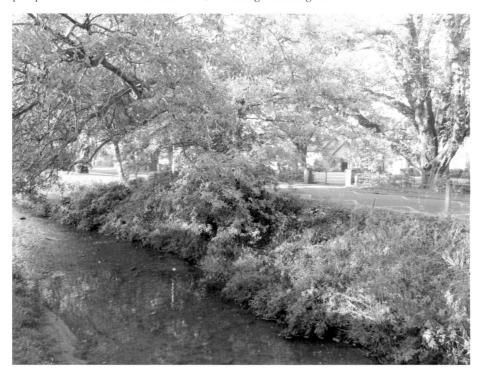

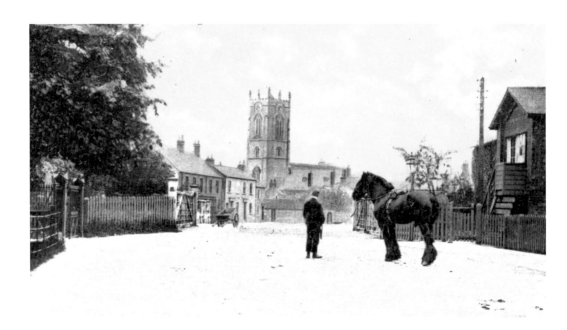

West Green Railway Gates and the Railway King

It was 'Railway King' George Hudson who won the contract to drive the railway through Pocklington as part of the York to Market Weighton line in 1847. Hudson's bankruptcy in 1849, however, delayed the extension to Beverley until 1865. Five passenger trains per day passed through Pocklington. The line was axed in the Beeching cuts of 1965.

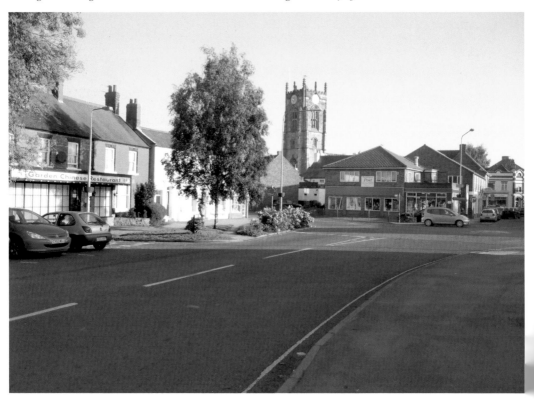

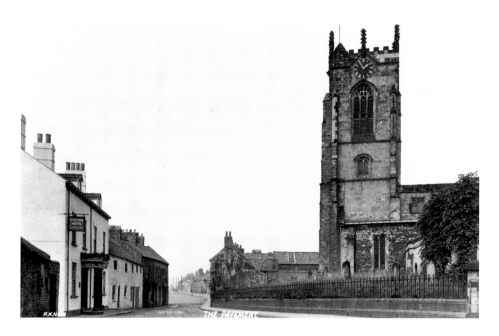

Pavement and the Cathedral of the Wolds

The present Norman church was built on existing Saxon foundations. Work began in 1190 on the church, which is largely Early English and Perpendicular in style. The 120-foot tower was completed in 1490. Local wool provided some of the capital for the building. The tomb of Thomas de Berewick, one of Norman England's wealthiest wool merchants, is located in the Barwyck's aisle.

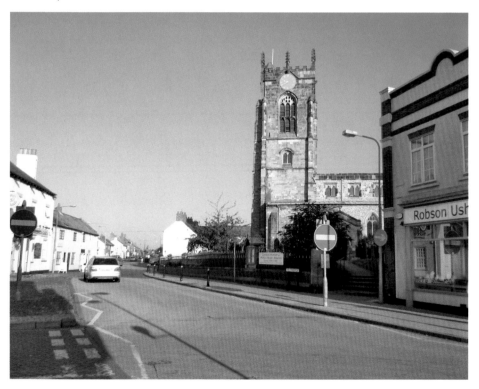

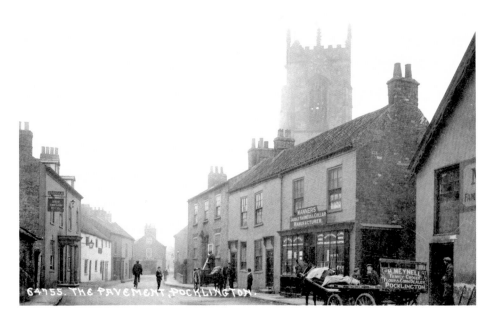

Pavement or Puddingate?

The Pavement with the New Red Lion Hotel on the left and Manner's the saddler on the right. Previous names for Pavement were Tute Hill and Puddingate. Tute Hill means 'lookout on the hill' in Anglo-Saxon; the street may have been the site of a prehistoric tumulus or of a Saxon manor house owned by Earl Morcar. There is evidence that he had a wooden castle here and an extant epic poem recounts how he was defeated at the Battle of Fulford and retreated to Pocklington before joining the battle at Stamford Bridge in 1066. Puddingate recalls the medieval offal used by the butchers here to make puddings.

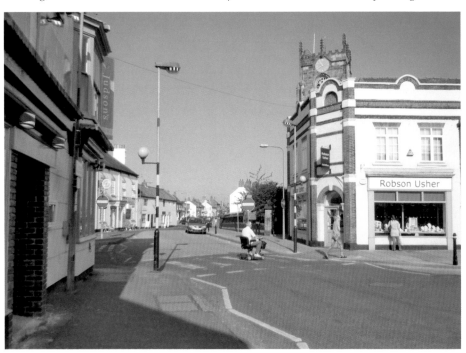

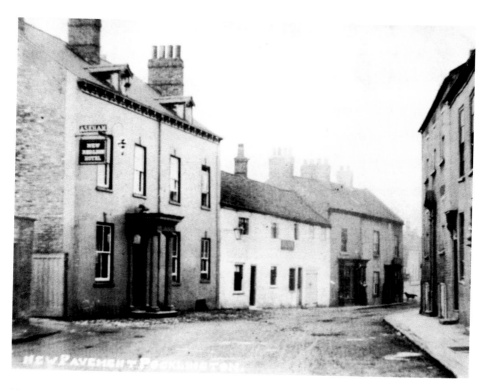

New Pavement, Dogs, Ducks and Lions

At the beginning of the nineteenth century the New Red Lion took the name the Dog & Duck; it changed back to the Lion after 1834 and then became the Station Hotel in 1924. The houses on the right bordering All Saints' Church were demolished in the 1890s and the 1930s.

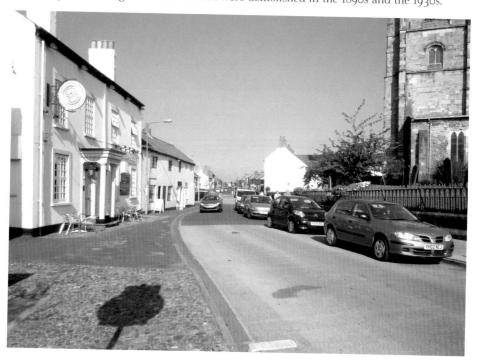

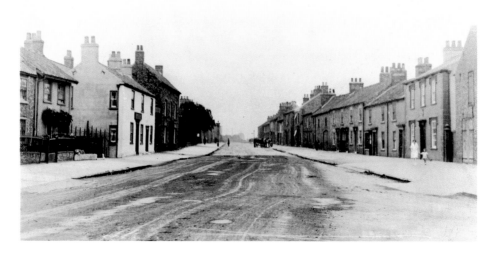

George Street and William Watson

Originally named Hungate and then Great George Street; the earlier name suggests the presence of wild or hunting dogs in the neighbourhood. William Watson (1784–1857) of Seaton Ross, the famous cartographer, land surveyor and dial maker, lived at No. 21. He produced two maps of Pocklington: one in 1844, the other, more detailed, in 1855 (see page 6). For the later map he painstakingly showed the houses' appearances with the names and professions of the people who lived in each of them. He drew similar maps for Seaton Ross and Market Weighton.

George Street Police Station

The 1897 police station is shown in the new photograph – the original one was on the other side of the road. The town council has taken over the adjacent old courthouse, which closed in 2001, thus ending a millennium of meting out local justice that began with the medieval Wapentake Court.

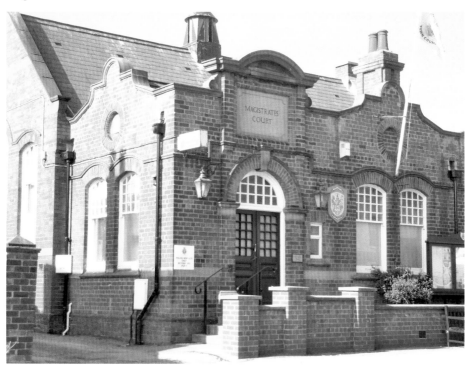

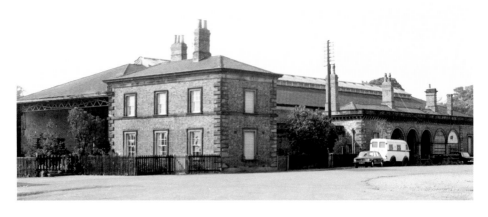

Pocklington Railway Station

The prolific George Townsend Andrews designed and built this fine Italianate station, which by common consent is one of the finest railway buildings in the British Isles. Apart from all of George Hudson's railway buildings (including York station – the biggest in the world at the time), Andrews' impressive portfolio includes the original buildings at York St John University, the de Grey Rooms in York, the Yorkshire Insurance Company building in St Helen's Square, York, the Halifax Infirmary, and the Montpellier Baths and the White Hart Hotel, Harrogate. Pocklington Station now serves as the sports hall for Pocklington School and is the venue of the 2011 'Pocktoberfest' (see page 32).

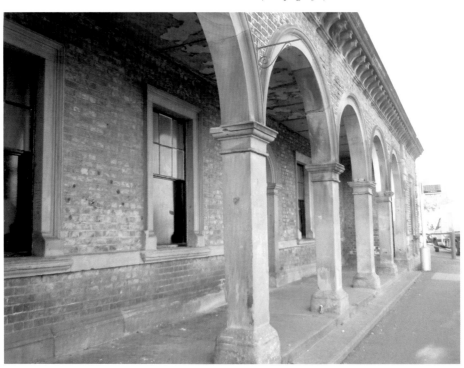

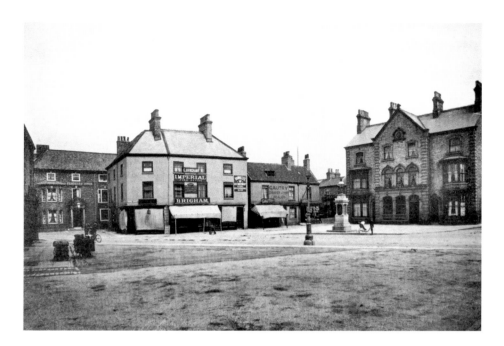

Market Place

Market Place has been the focus of Pocklington trade since the thirteenth century, and continues to be to this day with the Tuesday market. Brigham's Drug Stores can be seen in the centre with G. Brigham's fire insurance offices above. Gautry's draper and fent dealer, is to the right. Note the Victorian sign for Dunville's Old Irish whisky. The Feathers Hotel, historically a Tory meeting place, is out of shot on the left: former names were the Cut a Feather and Prince of Wales Feathers. Barclays Bank is the gabled building to the right.

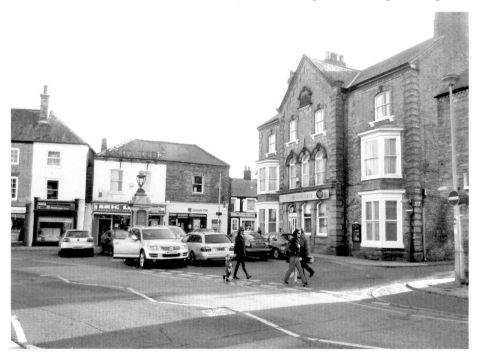

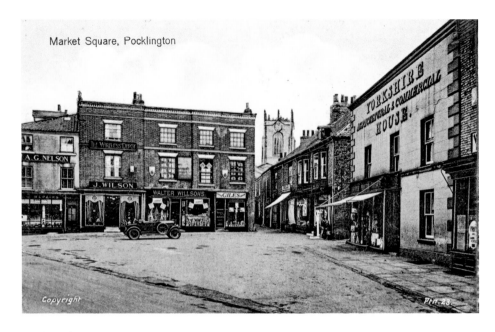

Market Square, Pocklington

Market Place

The imposing Yorkshire Agricultural & Commercial building is on the right, with Procter's, the draper's and hosier's, on the ground floor. Giles the tobacconist's, the wireless depot and a branch of Walter Willson's grocer's are in the centre and Nelson's boot repairer on the left. The building opposite Giles was Whitehead's printer and stationer.

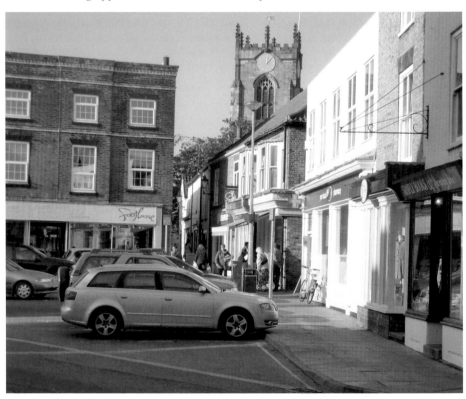

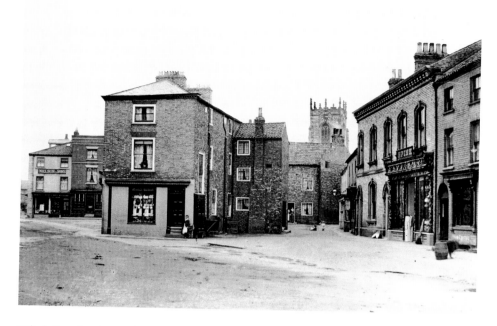

Witch Burning in Market Place

The same place but viewed further back with Spink's clearly visible on the right. Market Place was the venue for public executions, one of which took place in 1630 with the burning at the stake of Old Wife Green for allegedly being a witch. This was possibly the last witch-burning in England (although the last executions by hanging were of Temperance Lloyd, Mary Trembles, and Susanna Edwards who swung at Exeter in 1682); it could also have been a mob execution in reprisal for Green's murder of her husband.

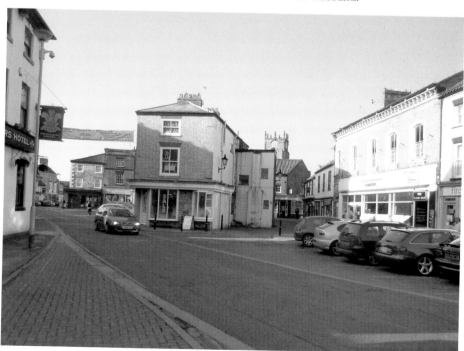

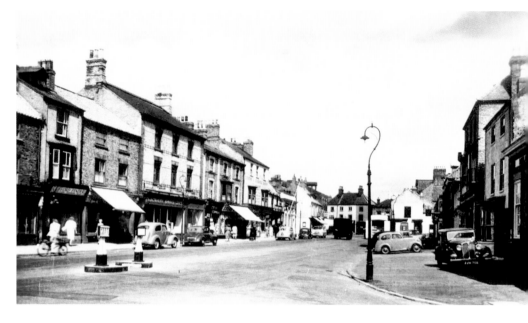

Joseph Terry, Confectioner

There are some splendid vintage vehicles in this shot of Market Place. It was here that Joseph Terry was born in 1793, the son of a farmer; he went to York to serve an apprenticeship in an apothecary in Stonegate. An advertisement in the *York Courant* in 1813 proclaims that he is established 'opposite the Castle, selling spices, pickling vinegar, essence of spruce, patent medicines and perfumery'. Later, he moved this shop to Walmgate where he practised bloodletting using leeches. After joining Bayldon & Berry's confectionery business he went on to establish the world-famous chocolate company, Joseph Terry & Sons.

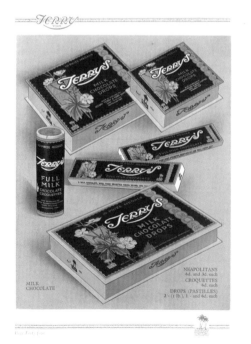

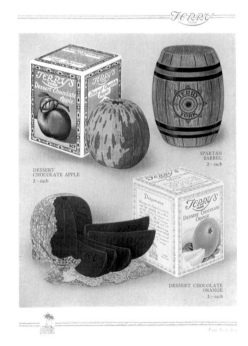

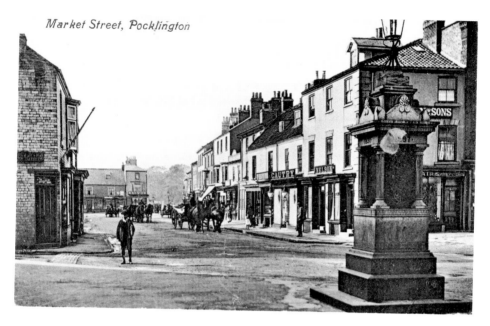

Market Street, Pocklington

William Ullathorne

Looking down Market Street, originally called Swine Market, around 1910, with the Queen Victoria Silver Jubilee Monument of 1897 prominent in the foreground. Behind the modern post office is the site of the eighteenth-century tannery, later to become Squire Denison's flax factory. Both of these businesses benefited from the beck, which was a mill dam. William Ullathorne also lived near here. The son of a shopkeeper, he went on to become Vice-General of Australia in 1833, and, on his return to England, was appointed a Roman Catholic Bishop in 1847 before becoming the first Roman Catholic Bishop of Birmingham. Ullathorne was a powerful force in the movement to abolish the transportation of criminals and later in the movement to outlaw public floggings.

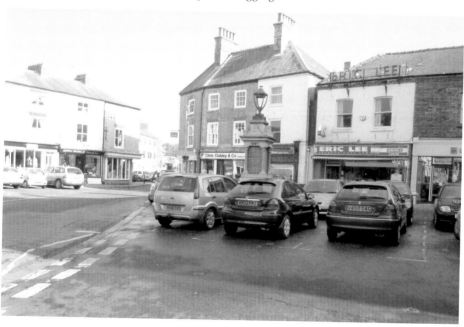

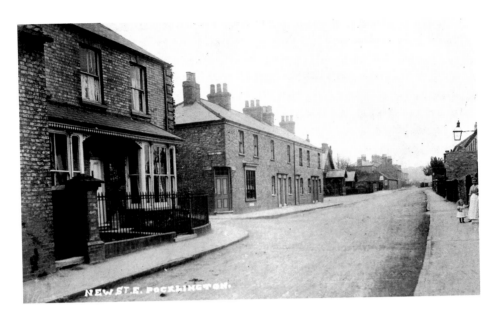

New Street

One of the more important buildings in New Street was the Albion Foundry where the mill wheel for the Devonshire Mill was made. Devonshire Mill in Canal Lane probably dates from 1808. It was largely built from the ruins of Londesborough Hall, which was demolished by the 6th Duke of Devonshire, who was looking for ways to finance the building of Chatsworth House – hence the mill's name. Henry Cains moved there from Clock Mill in 1848, adding steam power. His son Henry Parkin Cains took over in 1891 and ran it until the 1950s. A listed building, it is now a private residence and holiday home. The modern picture shows some fine terracing in New Street today.

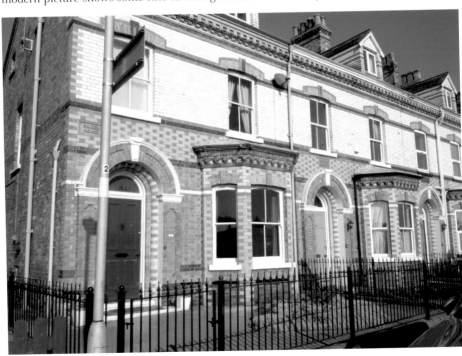

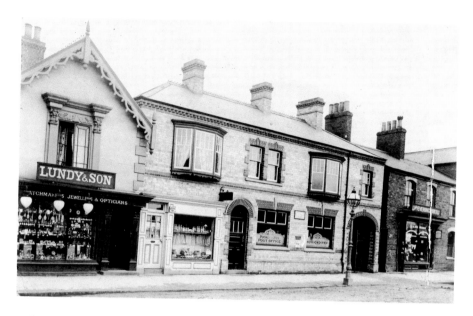

Railway Street

Two fine buildings here: on the left, No. 11, Lundy's the jeweller's, and in the centre the old post office. Originally named Finkle Street and East Green (*finkle* is a dog's leg in Dutch so Finkle Streets are usually a corner or crooked street) it was renamed with the arrival of the railways in 1847. Lundy's was originally an outhouse of the Dolmans' manor. The Dolmans bought the house from the Bishop family, one of whom was Thomas Bishop, a lackey of Henry VIII's, who was imprisoned three times in the Tower of London by successive monarchs. His son was less fortunate – he was beheaded in 1570 for his part in the Rising of the North.

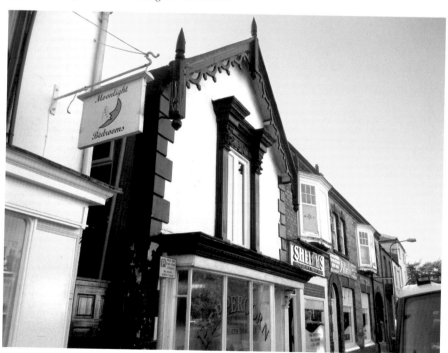

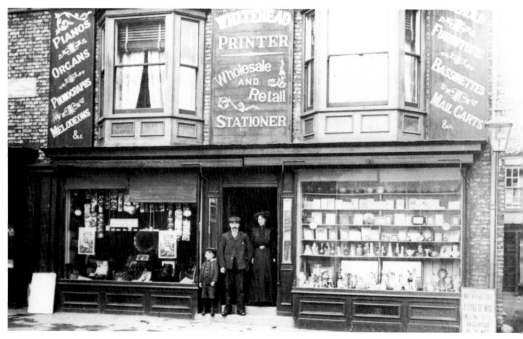

The people and places of

OLD POCKLINGTON

From The Archives Of
The Pocklington & District Local History Group

Andrew Sefton

Whitehead's Printer's

John Whitehead bought the *Pocklington News* (established 1876 by George Stancer) from Arnold Rapp in 1900. Apart from printing and publishing, and as well as selling stationery, Whitehead's was also a postcard emporium, a dealer in pianos, organs, phonograms and melodeons. It was also the place to go if you wanted a bassinet or mail cart – diversification indeed! The new photograph shows the modern face of local publishing, with the publication in 2010 of *The People & Places of Old Pocklington* by Andrew Sefton; a splendid evocation of the town told in old archive material from the Pocklington & District Local History Group.

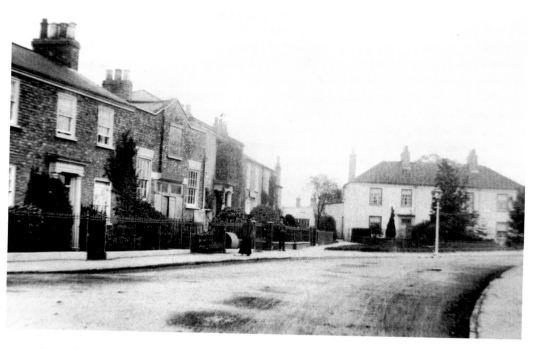

Bloomsbury House

Bloomsbury House was built in 1770 and takes its later name from the 25–1 winner of the 1839 Derby, ridden by local jockey Simeon Templeman. Templeman bought the house here with his winnings and went on to become a successful property owner. The Wilson Memorial Hospital is in the corner on the left (see page 26).

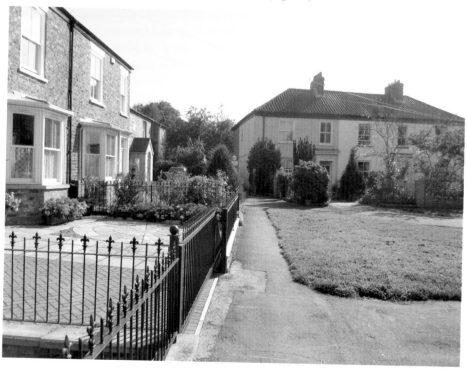

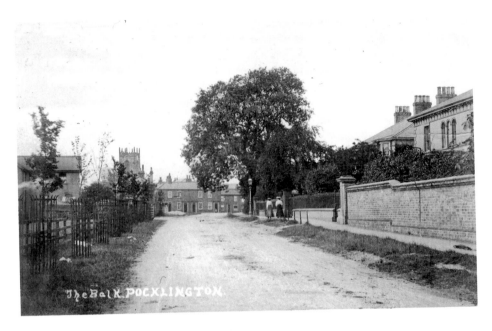

The Balk and the Founding of Christianity

Other fine buildings in the Balk include the 1880 Wilson Memorial Hospital; it commemorates Dr Thomas Wilson, local GP and historian, and was built by public subscription as a cottage hospital. Later it became the library (dedicated to Dr Wilson) and was afterwards used as council offices. Wilson argued that Pocklington was the site of King Edwin's assembly in 627, which led to the destruction of the pagan temple at Goodmanham and the establishment of Christianity in the north, thus making Pocklington an important player in early British Christianity.

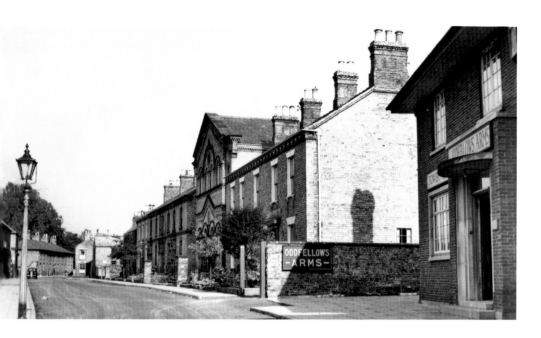

The Oddfellows Arms

This is located in Union Street and thus originally the Union Inn. It was renamed the Oddfellows Arms around 1840 after the Oddfellows Hall, built next door the year before (to the right, out of shot). The old photograph is from the 1950s. The grand building between the terraces is the Primitive Methodist chapel, regrettably demolished (see also page 34).

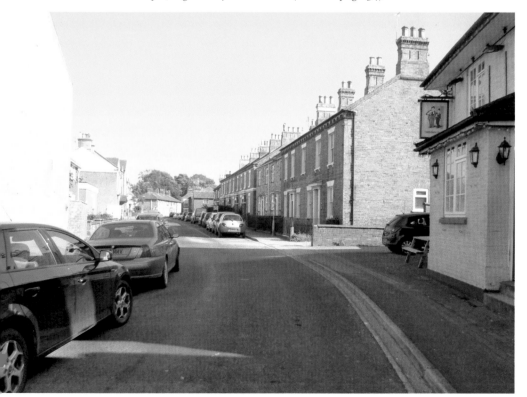

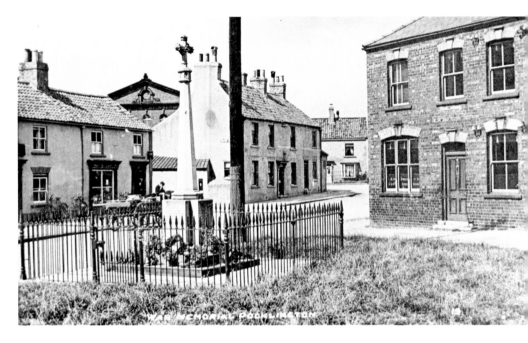

The War Memorial

Among the fifty-three men from Pocklington who died in the conflict was Lt Edward Moore Robson of the Green Howards. He was awarded the Military Cross at the Battle of the Somme but was killed in April 1918. Robson is famous for his cartoons of trench life: humorous drawings of the officers he knew, and 'fictional' sketches about the stereotypical British soldier.

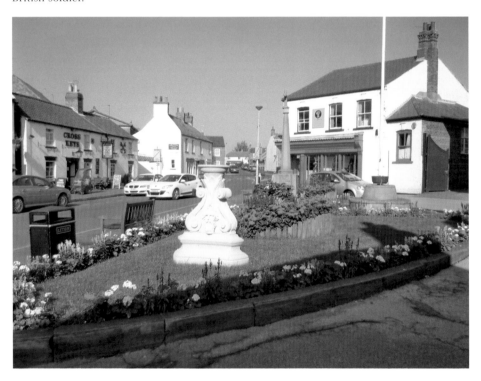

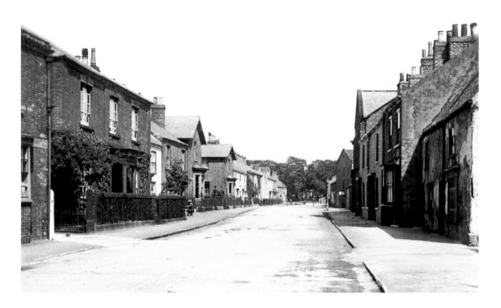

Chapmangate

A view of a virtually deserted Chapmangate. In Saxon and Viking times Chapmangate would have been an important part of town, named as it is 'the street of the merchants'. By the 1500s it was home to many of the wealthier Pocklington families. In the nineteenth century it was a veritable hotbed of religion, with the 1864 Grecian-style Wesleyan Methodist church, the 1852 Wesleyan school, a ladies' seminary at No. 4, the 1807 Congregational chapel, the Roman Catholic church and the first vicarage for All Saints' Church all situated here. Wells House is in the new photograph.

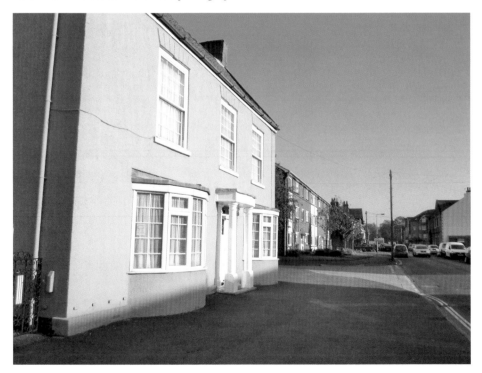

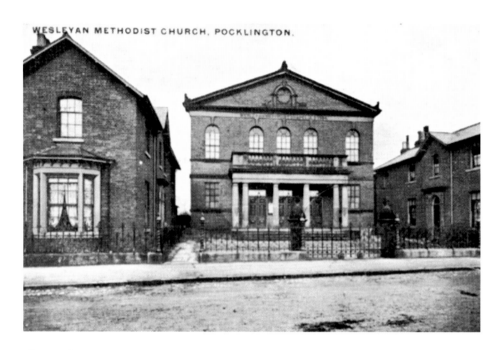

The Wesleyan Methodist Church

The Wesleyan chapel was built in 1864 to replace the 1813 chapel. Grecian in style, the portico boasts six Doric pillars. With room to accommodate 700 worshippers, the original total cost of £2,300 was raised by subscription. The two houses for the ministers flank the chapel. John Wesley visited the town to preach on no fewer than eighteen occasions from 1752.

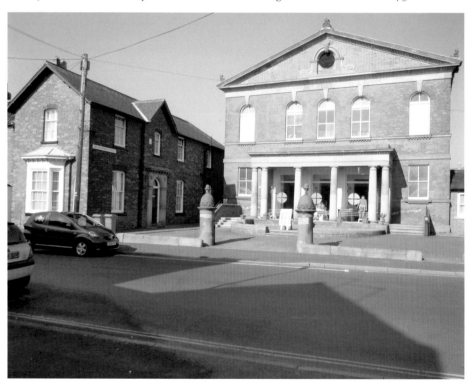

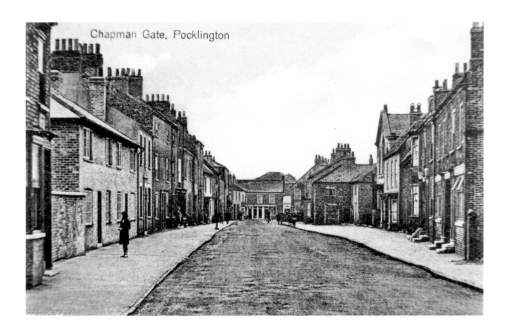

Chapman Gate, Pocklington

Chapmangate Mills

The street was also home to R. M. English & Sons Ltd, millers and agricultural engineers – following a tradition that saw two mills here at the time of Domesday and five during the nineteenth century. Before English took it over, the 1896 building was part of the flax mill here. Other uses have included a Salvation Army citadel, a corn mill and the Victoria Hall – an important meeting place in the town. R. M. English still trade in Market Street selling animal feed and pet foods.

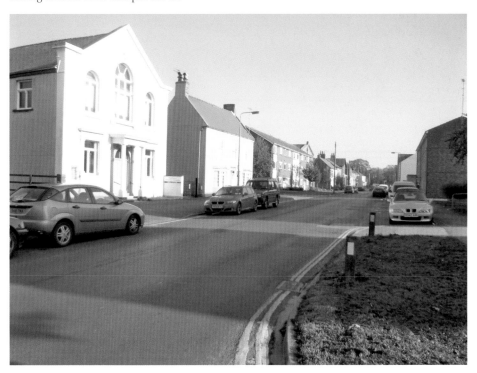

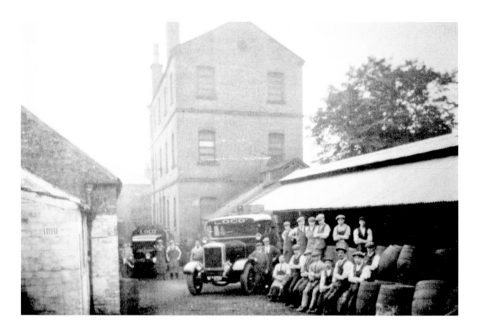

Loco Ales and Pocktoberfest

Chapmangate was also notable for its two breweries. The last one closed in the 1930s. When Young's Waterloo Brewery closed in 1911, the site was taken over by Robert Cattle. When Cattle Brewery closed soon after the First World War, Tadcaster Tower Brewery Co. took over, trading as York & District Clubs Breweries and producing the 'Loco Ales' from 1925. The town's connection with beer persists today with its pubs and the annual Pocktoberfest, a two-day beer and music festival in homage to Munich's Oktoberfest. The October 2011 event featured Billy Bragg, Thea Gilmore and 3 Daft Monkeys, as well as lots of beer.

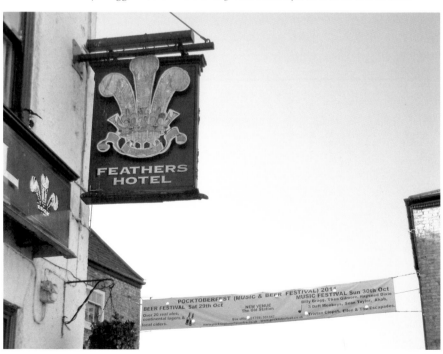

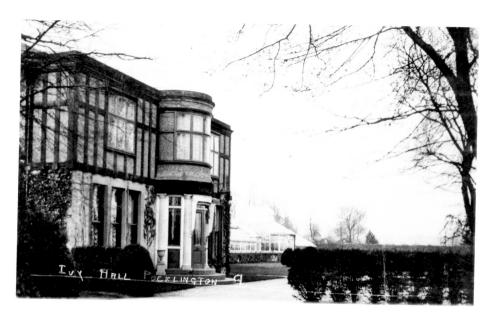

Ivy Hall and Major Percy Stewart

Burnby Hall (as Ivy Hall is now called) ornamental gardens and the Stewart museum provide a marvellous testament to the life of Major Percy Marlborough Stewart (1871–1962) explorer, collector and big game hunter. The museum contains many artefacts and trophies acquired during his world tours; the gardens can claim the largest collection of water lilies in a natural setting in Europe. Major Stewart and his wife Katherine were inveterate philanthropists and hosted annual Christmas lunches for the children, working men and poor of the town. They also taught fly-fishing to generations of Pocklington boys and were benefactors to many local clubs and organisations. On his death in 1962, Major Stewart left the gardens and the museum in trust for the benefit of the people of Pocklington.

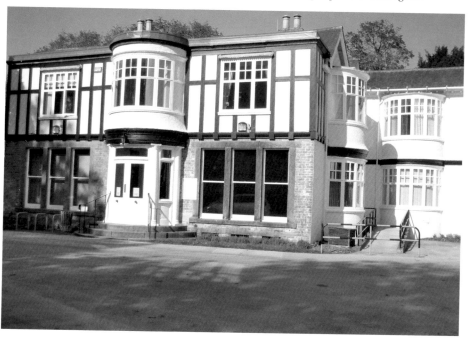

81 Union Street

The Oddfellows Hall was specially built for the Lord Byron Lodge of the Independent Order of Oddfellows Friendly Society. It held 400 people and was also the town's courthouse before the George Street courthouse was built in the late 1890s. The Literary & Philosophical Society also held their meetings there among the theatrical productions and concerts, and the *Pocklington News* was published here at one time.

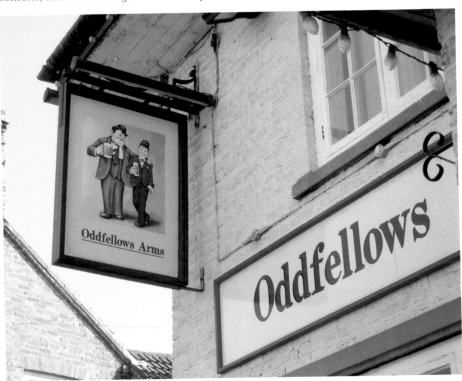

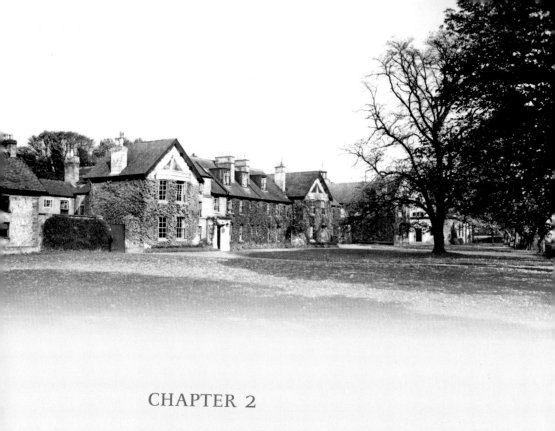

CHAPTER 2

Pocklington School

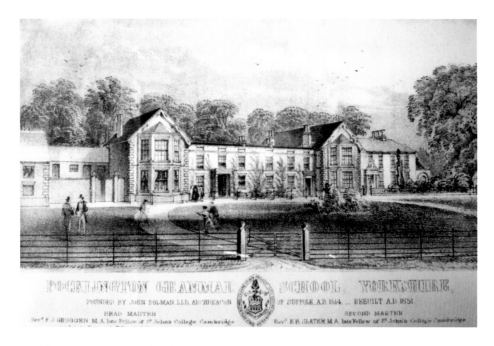

Pocklington Grammar School, 1851

Pocklington School was founded in 1514 by Dr John Dolman, Canon of St Paul's, as part of a licence granted by Henry VIII to establish a 'Guild of the name of Jesus, of the Blessed Virgin Mary, and Saint Nicholas, at All Saints' Church for a master, two wardens, and brothers and sisters'. In 1552 this was all transferred to the school, which by then was under the patronage of St John's College, Cambridge. As this picture shows, the original school was rebuilt in 1851.

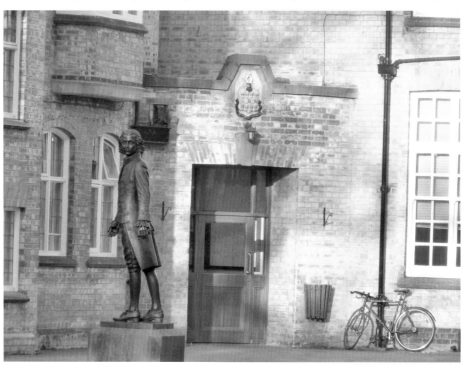

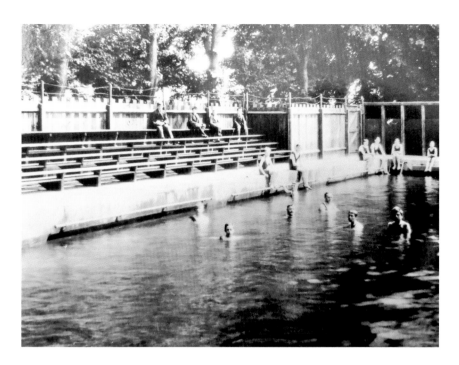

The Old Swimming Baths

The swimming vests would have done little against the cold on a typical Yorkshire day. The school has a fascinating heritage and much is done to conserve it. In April 2011 the go-ahead was announced for the establishment of a purpose-built museum and archive to house and display the many artefacts, photographs and documents relating to the school and its alumni; a marvellous and stimulating addition to the heritage and research facilities of both the school and Pocklington town.

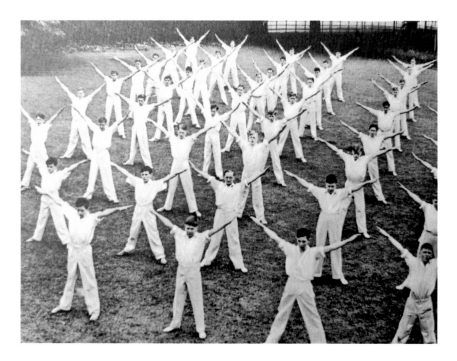

More Physical Exertion

A school gymnastic display. Old boys from the school include the Most Revd J. C. H. How, Primus of the Scottish Episcopal Church 1946–52; Lord Moran (Dr Charles McMoran Wilson), personal physician to Sir Winston Churchill from 1940 to his patient's death in 1965; and 2nd-Lt Richard Annand, awarded the Second World War's first VC for gallantry in Belgium in May 1940 while serving in the Durham Light Infantry. The newer photograph shows the school coat of arms above the entrance: *'Virtute et Veritate'* – 'by virtue and by truth'.

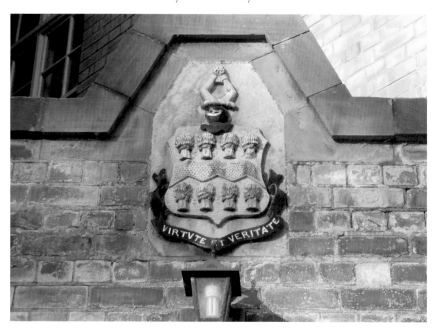

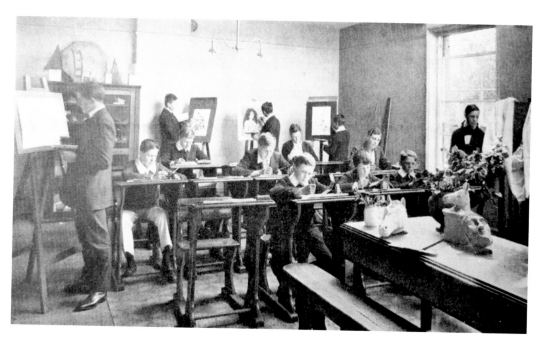

The Art Room

Pocklington School's most celebrated old boy is, of course, William Wilberforce. Born in Hull High Street in 1759 and baptised at Seaton Ross, he later attended Hull High School before staying for a period with relatives Wimbledon, where he became an evangelical Christian. On his return in 1771, William started at Pocklington School where he was educated until 1776 before going up to St John's College, Cambridge.

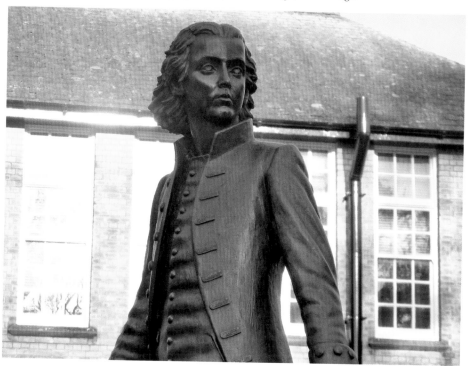

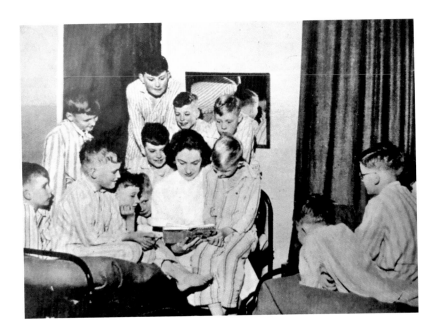

Bedtime Stories

Matron Doreen Arton reading an adventure story to some junior boys in Oxford Dormitory. The newer picture shows Lyndhurst today. Apart from his work as an abolitionist, William Wilberforce was heavily involved in a number of other contemporary social issues. He supported legislation to improve the working conditions of chimney sweeps and textile workers, was involved in prison reform and lent his support to campaigns to limit capital punishment; he promoted education as a means to alleviating poverty and helped found the world's first animal welfare organisation, the Society for the Prevention of Cruelty to Animals (later the RSPCA). He also campaigned against duelling, which he called the 'disgrace of a Christian society'.

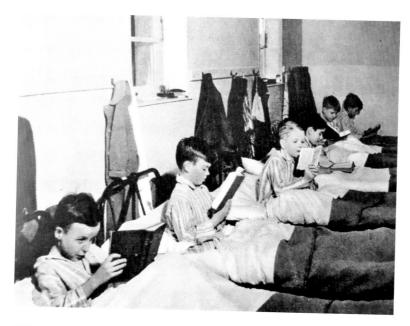

Bible Readings

Younger boys reading the Bible before going to sleep in Cambridge Dormitory. Between 1890 and 1910 the school was one of two in Britain that were pre-eminent in Hebrew Studies. Although Hebrew is no longer taught, Classics still is and open awards and State scholarships are regularly won to attend Oxford and Cambridge. The statue of the emancipated slave, sculpted by Peter Tatham (Pocklington, 1983–93) is located in the centre of the St Nicholas Quadrangle. A bronze statue of Wilberforce as a boy, by York sculptress Sally Arnup, stands near the school foyer. It was erected in 2007 to commemorate the 200th anniversary of slave emancipation, and was unveiled by Dr John Sentamu, Archbishop of York (see also pages 4, 36 and 39).

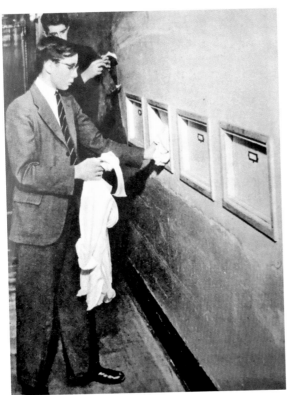

Dirty Washing

Boys could conveniently deposit their dirty washing for despatch to the laundry, presumably to be returned washed and ironed the following day. The philanthropy and social responsibility that characterised William Wilberforce live on today in the William Wilberforce Trust. This important and effective charitable organisation is working on a number of projects to improve life generally for those affected by debt, addiction, homelessness, unemployment, trafficking, sexual exploitation, depression, loneliness and vulnerability. This includes prisoners and ex-offenders as well as those in society at large.

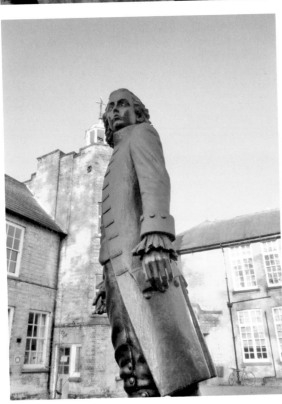

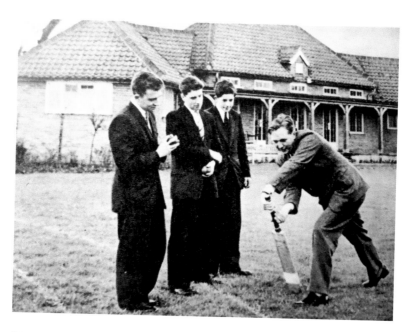

'Women Have No Brain Power'

Mr M. H. Stevenson, a Cambridge Blue, shows how to deliver a defensive stroke in front of the Old Boys' Presentation Pavilion. Debating has been a regular activity in the school since the first society was set up in 1894, with its debates reported verbatim in school magazines. A 2010 re-enactment of a 1913 motion for women's suffrage (defeated by twenty-two votes to eight – as it was, more or less, when it was first debated in 1897) drew the following as reported in *Pocklington 500 Issue 4*: 'Women have no brain power. They were never intended to think, or to cultivate their brain which could never conceive anything great, being intended rather for the house than for the House'. Other schools are available: the modern photograph shows the 1854 National School in New Street.

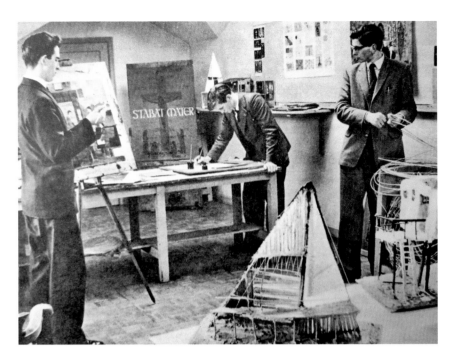

Arts & Crafts and Dvorak

Lettering and painting in the crafts room. Note the poster for Dvořák's *Stabat Mater*, about to be performed at the school. Other notable alumni include Sir Tom Stoppard 1950–54; Adrian Edmondson 1969–75, author, co-writer and star of *The Young Ones*; and Mark Fisher 1958–65, architect, designer of concerts for Pink Floyd, The Rolling Stones and U2, and chief designer of the opening and closing ceremonies at the Beijing Olympic Games, 2008. The modern photograph is of the school's library.

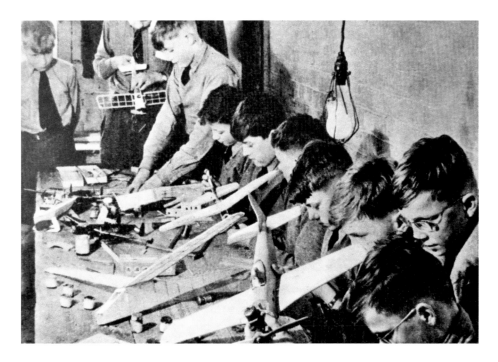

Aircraft Production and Pocklington Airfield

Constructing aircraft at Lyndhurst. Further down the road, Pocklington Airfield opened in 1941 and was the temporary home for around 2,000 servicemen and women, effectively doubling the town's population. Around 2,000 missions were flown in total, first by 405 Squadron Royal Canadian Air Force in Wellingtons and Halifaxes and latterly by 102 (Ceylon) Squadron RAF in Halifaxes. In 1943 alone 2,280 missions were flown; in 1944, 6,452 tonnes of bombs were dropped from Pocklington aircraft. To support the ill-fated Battle of Arnhem the squadron dropped 134,250 gallons of petrol for the Allies in 179 missions.

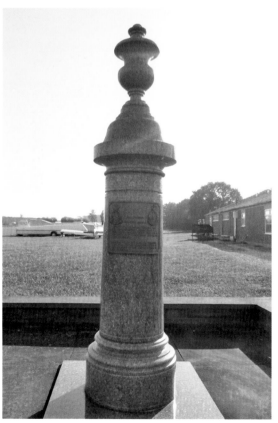

Aspects of Life at Pocklington School
Many aspects are shown here, including (top) the Combined Cadet Force moving their 25-pounder field gun, (top right) how to hurl a discus as demonstrated by another Cambridge Blue, A. J. Maltby, (middle) chemistry practical under Mr Allen, and (right) spectrometry in the physics lab. The newer picture shows the monument at Pocklington Airfield to those servicemen who lost their lives at Pocklington during the Second World War.

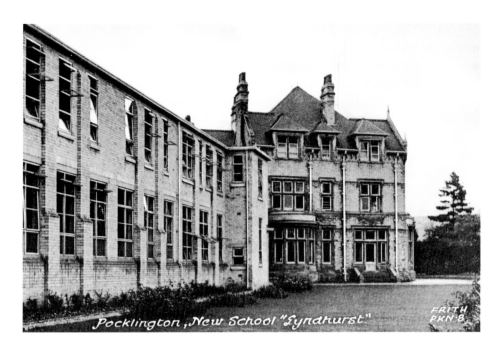

Pocklington, New School "Lyndhurst." FRITH PKN 8

Lyndhurst

In 1951 the new junior school for sixty boys aged eight to twelve (over half of whom boarded) was opened at Lyndhurst on Kilnwick Road. In 1960 there were four boarding houses in the school with 235 boys boarding out of a total roll of 405. The house was originally owned by R. M. English, of local milling fame, and is now a nursery school.

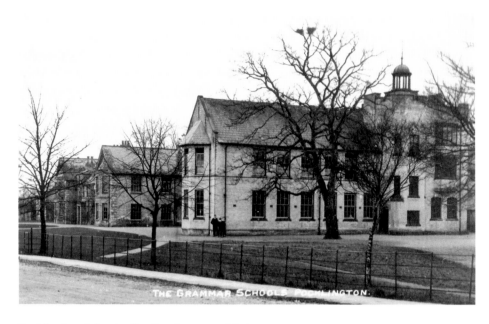

Pocklington School – for Gentlemen and Labourers

The occupations of the fathers of the boys in the school in the 1650s makes interesting reading: Gentlemen 52, Labourers 28, Esquires 10, Clergy 8, Merchants 7, Knights 5, Yeomen 4, Blacksmiths, Butchers, Lawyers and Tailors 2, Bakers, Scribes and Soldiers 1. Socially balanced as this may seem, few of the poorer boys went on to higher education, unlike their more affluent colleagues.

CHAPTER 3

Market Weighton

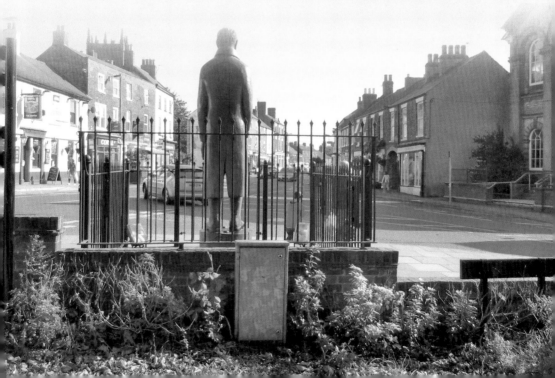

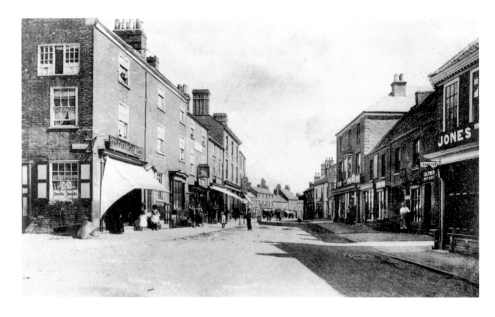

High Street

The Domesday Book tells us that Market Weighton, known then as 'Wicstun', formed part of a district of 15 villages and 117 farms, with the value of £30. Archaeological finds, however, indicate human activity in the area for over 7,000 years. Peg Fyfe lived hereabouts. She was a local witch who is said to have skinned one of the townsfolk alive in the 1660s. Sentenced to be hanged, she avoided the drop by swallowing a spoon. Unfortunately, two knights who happened to be passing were not going to allow such a miscarriage of justice and duly finished her off.

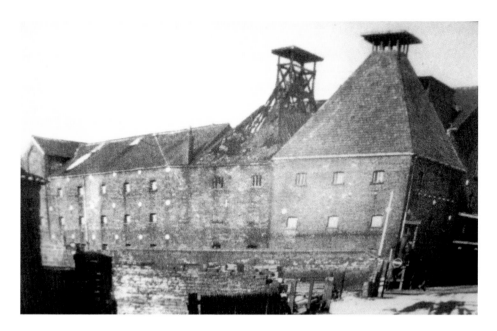

The Old Brewery

A picture of the brewery after the devastating fire. The newer photograph shows part of the pleasant and peaceful St Helen's Square area of town, site of the duck pond, village pump and some very fine buildings, including the old school (in the distance), the Tryste House, built in 1791 by Robert Shields (a school until the 1960s), and the 1843 courthouse and police station, in use until 1903. The modern apartments here have been built to reflect the original design of the brewery as closely as possible.

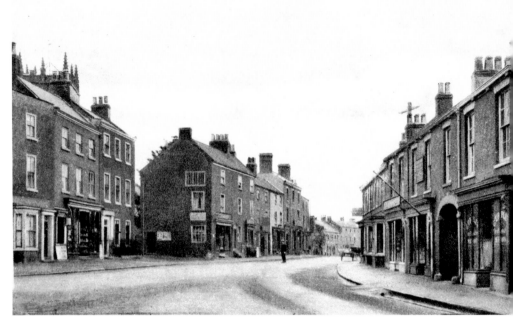

William Bradley

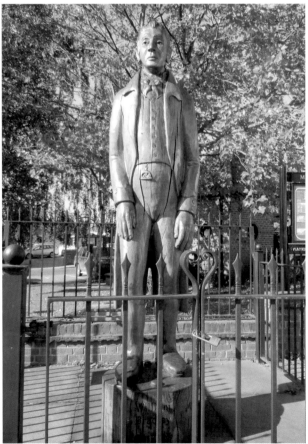

William Bradley is probably
Market Weighton's most
celebrated resident (see pages
4, 49 and 58). His house in
Northgate, now 89 York Road,
was specially adapted for him,
with rooms and doorways made
large enough to accommodate
his exceptional build. A plaque
on the wall outside shows his
remarkable footprint. The life-
sized wooden statue of the
Yorkshire Giant was unveiled
on Giant Bradley Day, 27 May
2007. It was carved by Malcolm
MacLachlan, from a 200-year-old
English oak log that was growing
in Bradley's lifetime. By amazing
coincidence, Edwin Calvert was
born in nearby Shiptonthorpe
– a man who grew only to the
height of 3 feet; he died aged
seventeen through excessive
alcohol consumption.

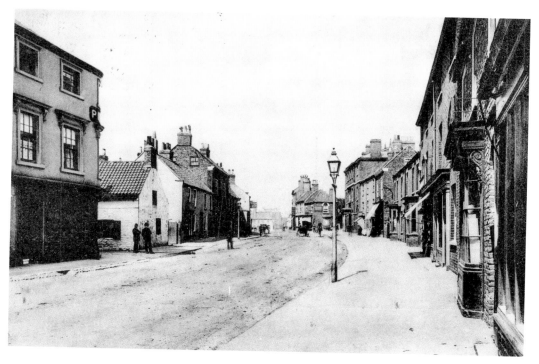

St Helen's Square

Other fine buildings clustered around the Square include the old fire station, operational until 1967 and once a mortuary, and the eighteenth-century manor house, once owned by the Londesborough family. The 1791 Georgian tryste house on the next page was Wicstun Junior High School, or Miss Penty's.

The Kiplincotes Derby

Reputedly the oldest flat race in the world, the Kiplincotes Derby was first run in 1519 and is still run today. However, it was 1618 before the rules were established. The 4-mile course follows a Roman road from the old Kiplingcotes station to Londesborough Wold Farm and was established to allow the local gentry to try out their horses after the winter, hence the March date. This is how it was announced in 1618: 'A horse race to be observed and ridd yearly on the third Thursday in March; open to horses of all ages, to convey horsemen's weight, ten stones, exclusive of saddle, to enter ye post before eleven o'clock on the morning of ye race. The race to be run before two.' The prize money for the winner is £50, although the runner-up can win more as all the entrance fees go to the second horse home. The number of runners and riders is unknown until the morning of the race.

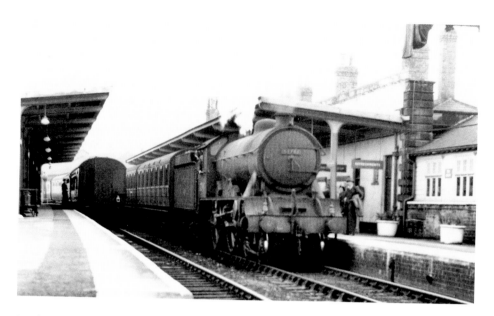

Market Weighton Railway Station

The important line between York and Hull, passing through Pocklington and Market Weighton, was opened to Market Weighton in 1847 with three trains each way every day except Sunday. It was built by George Hudson, the 'Railway King', who lived at nearby Londesborough Hall and enjoyed his own halt at Shiptonthorpe. The extension to Beverley opened in 1865. Both lines closed in 1965 despite fervent local protests and the station at Market Weighton was demolished. A 10-mile railway walk between Beverley and Market Weighton, the Hudson Way, survives. Station Farm in the 2011 photograph shows the Londesborough coat of arms above the door.

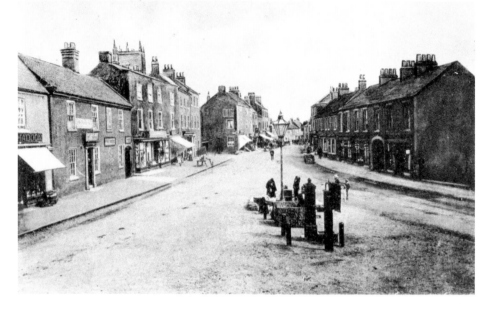

Market Place

The pictures show the village pump, once in the High Street and now in St Helen's Square. Henry III granted the town a Royal Charter in 1251, making way for a weekly market on Thursdays. Later, Lord Vespi repealed the charter and changed market day to Wednesdays; the weekly market is now held each Friday. Between 1700 and 1850, Market Weighton's September Fair was described as 'probably the greatest sheep fair in the kingdom with 70,000 to 80,000 animals annually exposed for sale'.

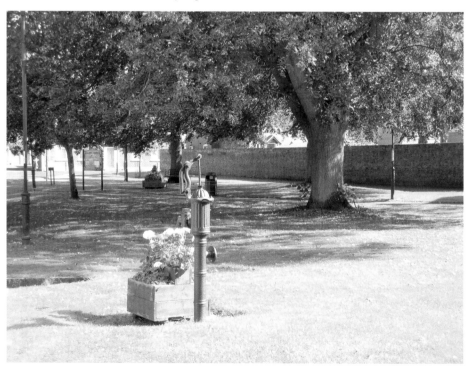

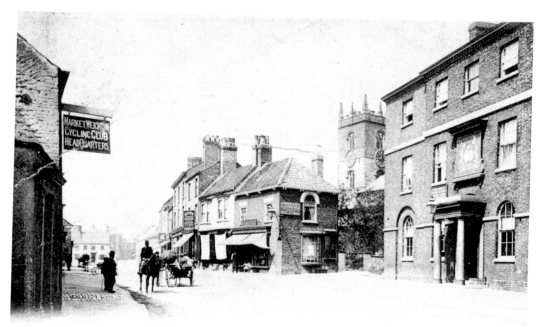

Market Place, Market Weighton.

The Londesborough Arms

The eighteenth-century Londesborough Arms was an important coaching and posting inn on the York–Hull road. Originally called the Briggs Inn, in 1825 it was renamed the Devonshire Arms after the 6th Duke of Devonshire, and then in 1845 became the Londesborough Arms when the Londesboroughs took over as lords of the manor.

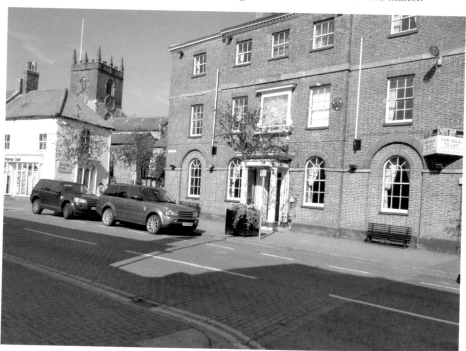

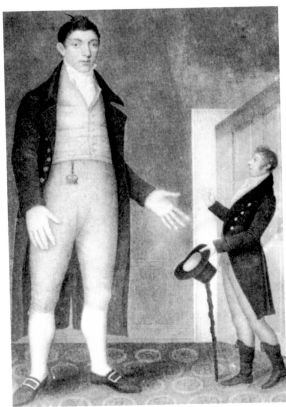

The Yorkshire Giant

William Bradley reached his full height of 7 feet 9 inches aged 20 when his weight was 27 stone. His footprint was 15 inches long and 6 inches wide. A star attraction at fairs throughout England, he charged people a shilling to shake his hand. George III presented him with a gold watch and chain when they met, which Bradley proudly wore for the rest of his life. He is now buried inside All Saints' Church, after a re-interment to foil grave robbers, and is celebrated every May on Giant Bradley Day.

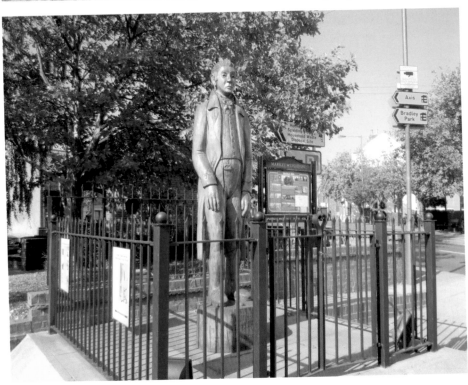

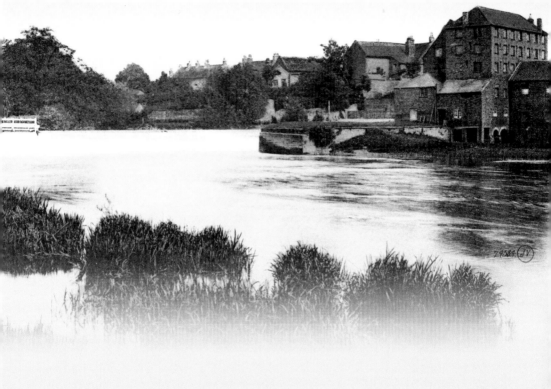

CHAPTER 4

Stamford Bridge

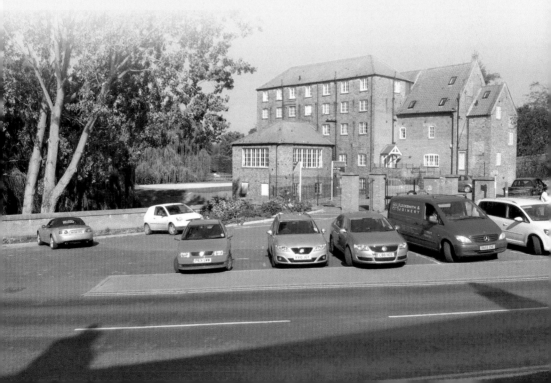

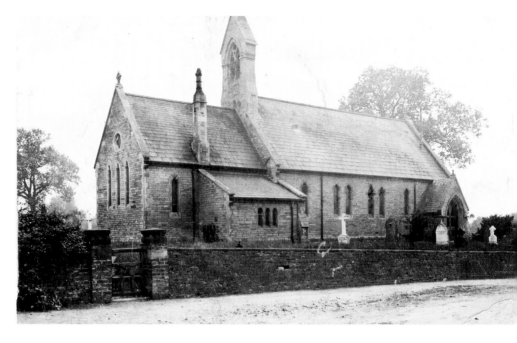

Stamford Bridge Church

A chapel, with a hermit, is recorded at Stamford Bridge in 1348. In 1444 a chapel was to be found on the bridge and a chantry chapel of St Edmund existed in 1466. St John the Baptist Church was built in 1868 as a chapel of ease in Early English style.

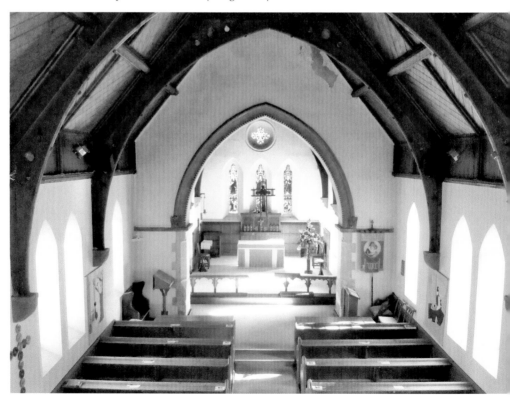

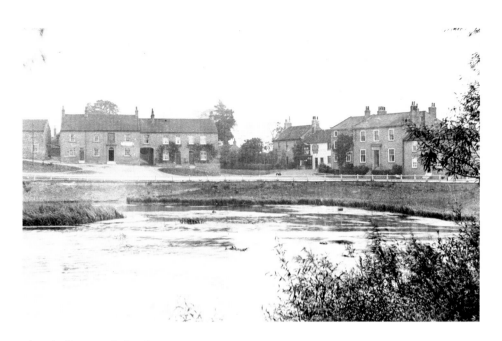

The Shallows and Flooding

Stamford Bridge has a long history of flooding, much of it in recent times. In March 1999, a combination of rainfall and melting snow on the North York Moors left much of the town under nearly 5 feet of water. The River Derwent peaked at 16½ feet above its normal level and this was the highest level ever recorded, exceeding the previous record of 1931 by 20 inches. In October 2000 the Derwent flooded again and peaked just above the 1999 level. New flood defences were completed in 2004 but these were breached in June 2007, leaving much of the square underwater again.

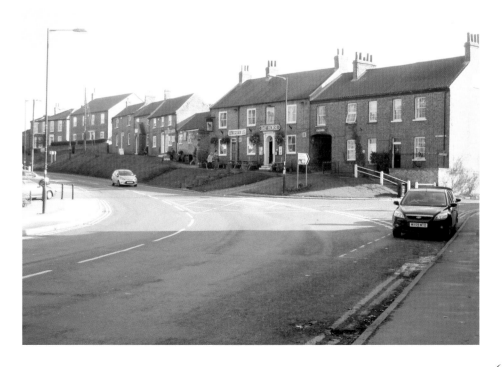

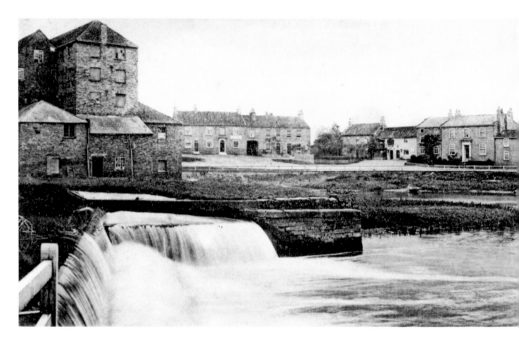

Mill and Weir

The Romans built a temporary marching camp close to here in around AD 70, leading to a later civilian settlement clustered around a bridge 1 mile south of the present one. *Iter I* of the *Antonine Itinerary* (a work of the third century, sponsored by the Emperor Caracalla) lists the settlement, Derventio, as being 7 Roman miles from Eboracum (York).

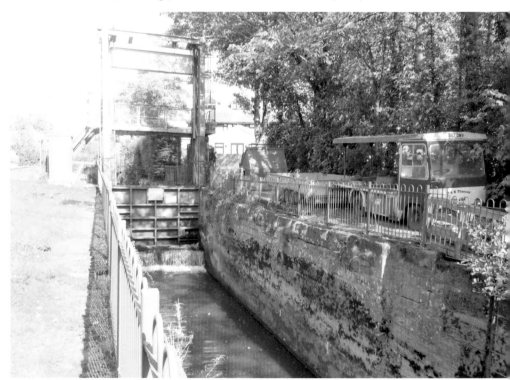

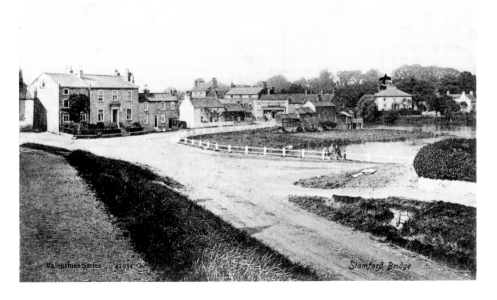

The Battle of Stamford Bridge

In the early autumn of 1066, Harold Godwinson's English throne was under serious military threat on two fronts: from Harald Hardrada (with Harold's disaffected and exiled brother, Tostig Godwinson) in the north and from William of Normandy in the south. York capitulated to the Vikings and left Harold in a quandary: to meet Hardrada in battle and then go on to deal with William or to head south immediately. In the event Harold came north and joined battle with Harald here at Stamford Bridge winning a total and militarily impressive victory.

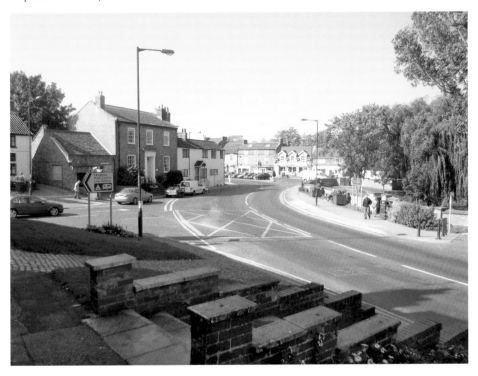

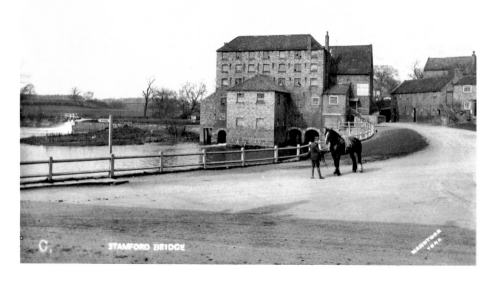

The Corn Mill

The corn mill we see here was built in 1591 and is reputedly at least the third mill to have been built here using the same foundations. Indeed, records show that there have been mills in Stamford Bridge from around 1135: 'seven mills on one pond in the Derwent' were recorded in 1258. A fulling mill was recorded in 1331 and in 1352 there were three corn and two fulling mills. The 1258 mill was extended in 1850 and eventually comprised two waterwheels and seven pairs of grinding stones. This mill closed in 1964 and became a restaurant in 1967; it is now comprised of apartments with interior design by local company 'Art from the Start', based in High Catton.

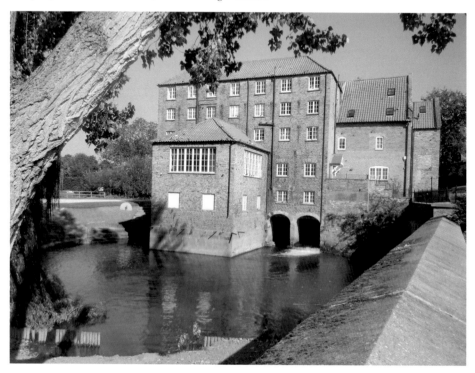

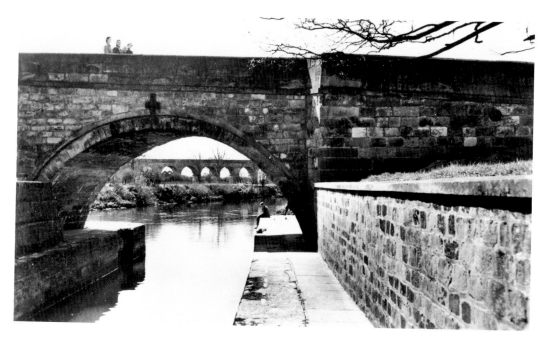

Bridge and Viaduct

The Normans called the town *Pons Belli* – Latin for 'Bridge of the Battle'. The majestic viaduct in the background, the only substantial one in East Yorkshire, opened on 3 October 1847 to carry the York to Beverley line across the Derwent on fifteen brick arches and an iron span. On 27 November 1965 the last train made the crossing and the line was closed; it is now a popular cycle route.

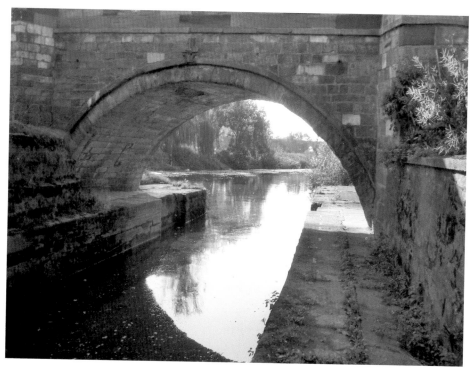

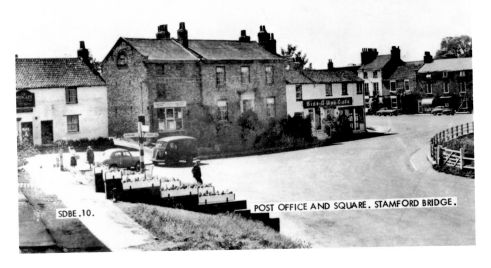

POST OFFICE AND SQUARE. STAMFORD BRIDGE.

SDBE.10.

The Post Office and the Stamford Bridges

In Roman times the River Derwent was usually fordable 250m upstream of the current bridge. A bridge near the village is referred to in accounts of the 1066 battle, as noted in the *Anglo-Saxon Chronicle*. A timber bridge supported by three stone piers was erected in the thirteenth century and repaired in the sixteenth century. A 1724 map has it 70m upstream from the present bridge.

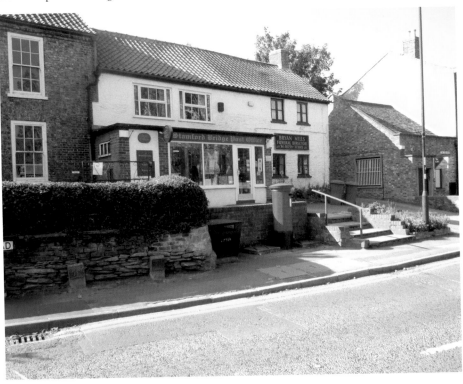

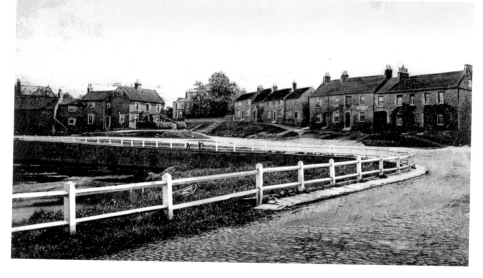

Stanford Bridge, Chelsea

There is, of course, at least one other famous Stamford Bridge in England. Maps from the eighteenth century show Stanford Creek, a tributary of the Thames, following the course of a railway line at the rear of Chelsea FC's East Stand. This was bridged by Stanford Bridge on the Fulham Road and Stanbridge on the King's Road, now known as Stanley Bridge. The 'n' changed to 'm' and Stanford Bridge, no doubt aided by association with the battle, became Stamford Bridge. Stamford Bridge, Chelsea, originally opened in 1877 as the home of the London Athletics Club until 1904.

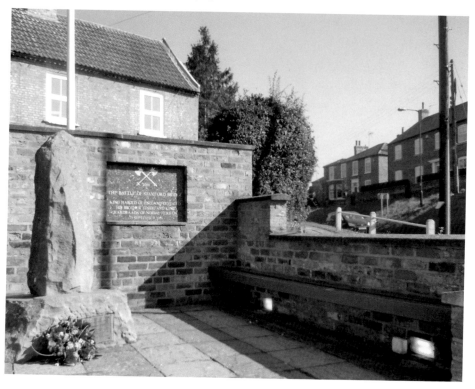

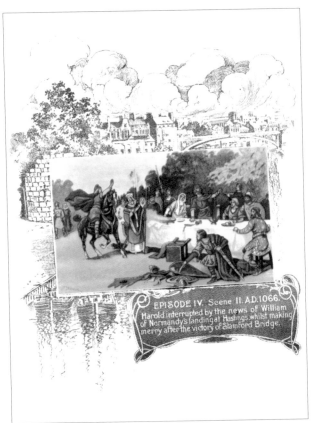

Making Merry at Stamford Bridge

The Battle of Stamford Bridge, 25 September 1066, was pivotal in British history, marking as it does the end of the Viking Age in Britain. The old illustration shows *Episode IV Scene II* of the *1909 York Pageant* in which 'Harold [is] interrupted by the news of William of Normandy's landing at Hastings, while making merry at Stamford Bridge' (originally published in a 400-copy limited edition of *The Book of the York Pageant 1909*, Ben Johnson & Co, Micklegate, York, 1909). The new picture shows a Viking hero defending the bridge, as described on page 69.

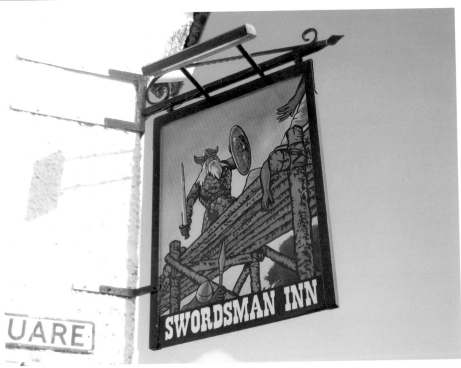

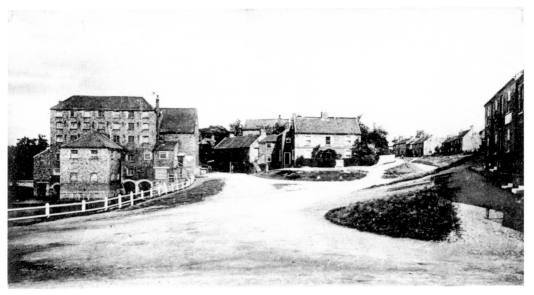

The Death of Harald and Tostig

The aftermath of the battle is interesting: both Harald and Tostig died in the slaughter; the *Anglo-Saxon Chronicle* tells us that only twenty-four ships were needed to get the Viking survivors home – they had come in 300. One of its more famous episodes, perhaps a legend, tells us that a Viking warrior stubbornly blocked a bridge over the Derwent, preventing Harold's armies from crossing until an English soldier leaped into the river and stabbed him from beneath. It is featured in the *Anglo-Saxon Chronicle* Manuscript C, but only as a later interpolation (see page 68).

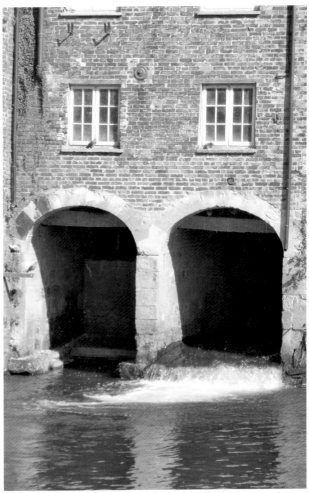

The Square

The somewhat unassuming stone commemorating the battle was erected here in 1956. The Derwent was navigable up to Stamford Bridge in the Middle Ages until 1602 when a new weir was built. It was made navigable again in 1702 and in the 1720s a cut with a lock was built bypassing the mill. The river carried coal, lime, corn and flour; there were stables, a warehouse, a coal yard and a lockkeeper's house in the town.

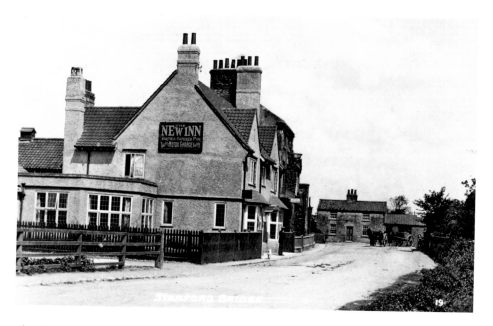

The New Inn

Stamford Bridge has never been short of public houses. The Three Tuns, recorded in 1823, is lost to us but the Bay Horse and the New Inn, mentioned in records in 1823 and 1840 respectively, remain open. The New Inn was renamed the Swordsman in 1974 to celebrate the town's Viking heritage. The Jolly Sailors, mentioned in 1840, was possibly the Hope & Anchor, known from 1851 and last recorded in 1892. The Three Cups on York Road is reputedly on the site of a camp for soldiers waiting to take part in the battle; an ancient, 23-foot-deep draw well, discovered during building works in the 1960s, can still be seen today through a porthole in the floor.

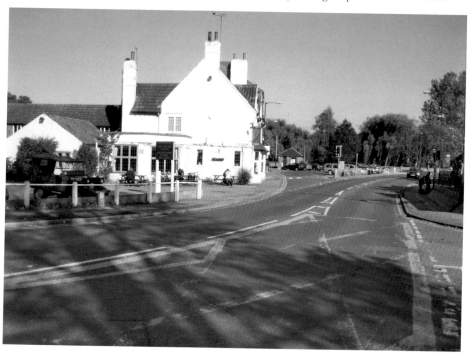

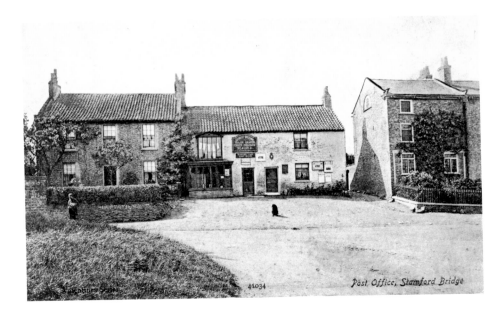

Post Office, Stamford Bridge

41034

The Volsung Vikings

The photographs show the post office and the Bay Horse pub opposite. In September 2011 a longboat full of Viking warriors rowed up the River Derwent to Stamford Bridge where they set up a 'living history' encampment showing Viking military life, engaging in a number of activities over the following days. These included weapon and combat displays, warrior training, Viking coin making and Viking crafts and games. In 2010 more than 100 Volsung Vikings realistically (within reason) recreated the battle, complete with boat-burning. The Volsung Vikings are the York-based branch of 'The Vikings', a national re-enactment society.

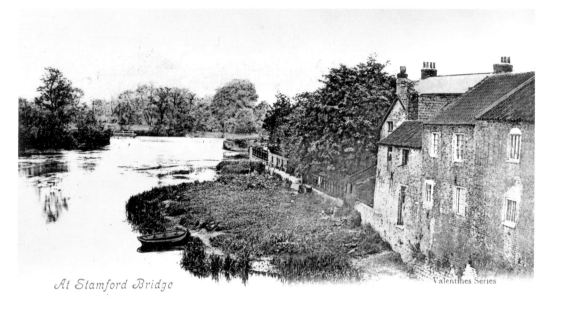

At Stamford Bridge

Valentines Series

The Shallows

The Shallows were part of the mill pond and have now been filled in. The area around the mill was landscaped in 1972 and, as the newer photograph shows, provides an attractive and peaceful place for ducks, geese, residents and visitors alike.

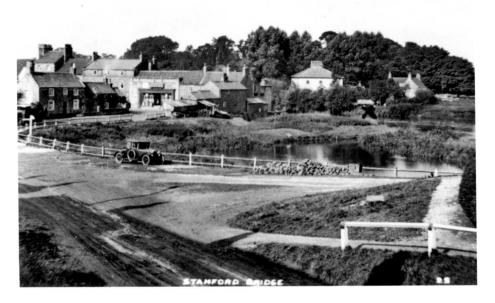

William Etty's Bridge

In the eighteenth century, the New Cut – the weir and the bypass canal and lock – was built and the medieval bridge was replaced with the one we see today. Designed by famous York artist William Etty, it was opened in 1727 and is a Grade II listed monument. The parallel steel bridge for pedestrians was opened in 1967.

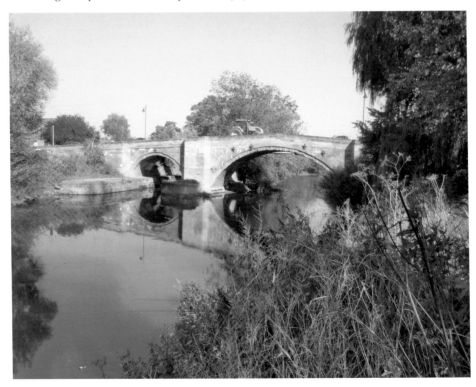

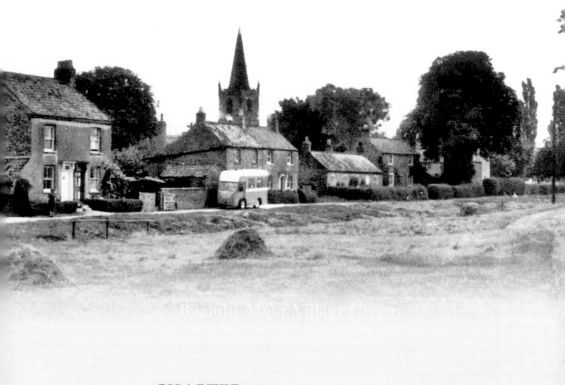

Barnaby Moor Village Green

CHAPTER 5

The Surrounding Villages

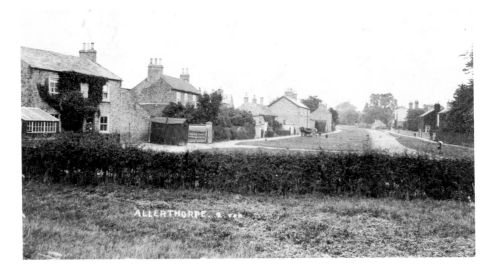

Thomas Cooke and Allerthorpe

Allerthorpe's most famous son is Thomas Cooke (1807–68). After two years of schooling money ran out and so Thomas taught himself maths and navigation with a view to a career in exploration. However, he took up the post of schoolmaster instead and started making lenses, which led to him opening an optometrist's in York's Coney Street in 1829 where he made his first telescope. He soon built a reputation for instruments of the highest quality and in 1856 went on to found the company that became the world-famous Cooke, Troughton & Simms in Bishophill, York, which was taken over by Vickers in 1915. Of the many telescopes he made, one was for a Gateshead millionaire. The telescope tube was 32 feet long and the whole instrument weighed 9 tons – the biggest telescope in the world at the time. The new picture is *Commencement of the Total Eclipse of 28 July 1851 at Blue Island Norway* from a watercolour by Charles Piazzi Smyth; the telescopes included those made by Cooke, Troughton & Simms.

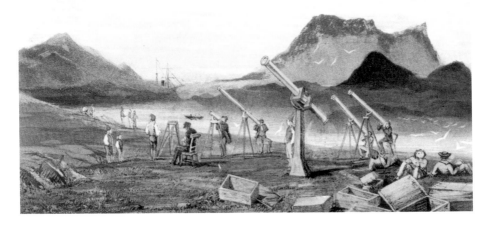

Barmby Moor

Originally a Scandinavian settlement called Barne's farm, it was Barmby in the late thirteenth century and then Barnby. The suffix 'by Pocklington' was adopted in the fourteenth century, interchangeable, it seems, with 'in the Moor' or 'upon the Moor'. In 1935 the name we know today was officially adopted.

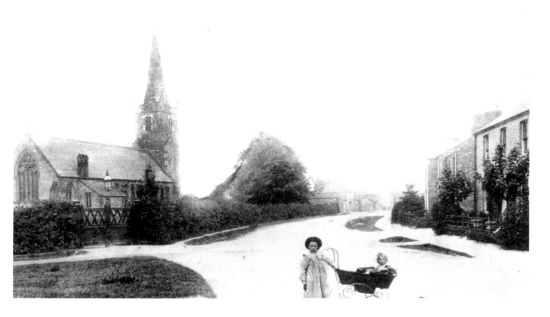

Barmby Public Houses

Barmby has enjoyed a number of pubs over the years: The George existed in the late seventeenth century, and an inn run by the occupant of Barmby Moor House was open on the road to the south of the village in 1770. About the same time Thomas Heard (*d.* 1824) established the Barmby Moor House, also known as the Bunch of Grapes, and later the Wilmer Arms, which closed in the 1850s. The Boot & Slipper opened around 1823, known then as the Boot & Shoe (see page 81). St Catherine's church is the church in the background.

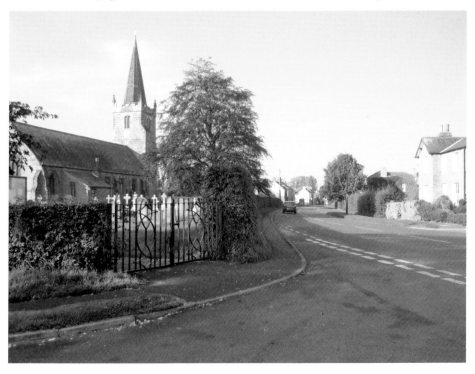

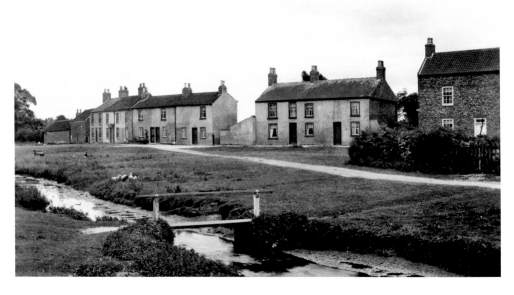

Ulf, Prince of Deira, John Le Poer and Henry of Helium

Barmby's early history pre- and post-Conquest is detailed in *A History of the County of York East Riding Volume 3*; it tells us that 'Ulf, the son of Torall a prince of Deira, gave Barmby to York Minster before 1066, and 7 carucates and 2 bovates there were held by the archbishop in 1086 ... the king had 6 bovates in Barmby as soke of his manor of Pocklington in 1086, but by 1198 John le Poer had been granted the estate, which he held with land elsewhere by the service of providing an archer for the defence of York castle. William le Poer quitclaimed some Barmby property to Henry of Helium in 1235'.

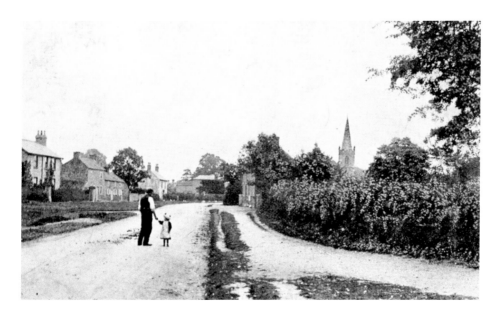

Barmby Schools

The first school here was recorded in 1743 at which the parish clerk gave religious instruction. In 1819, an unendowed school educated twenty or so children and, by 1824, reading, writing, and accounts was on the curriculum and taught by a schoolmaster who was paid for along with coal, stationery and books by trustees of the Poor's Land charity. In 1835, thirty-eight children were being taught in two schools and paid for by their parents. There were also two dame schools. The modern shot shows some of the fine houses around the green; note the impressive clock on the front of the one on the right.

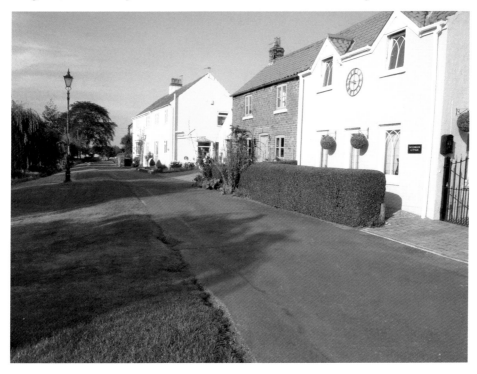

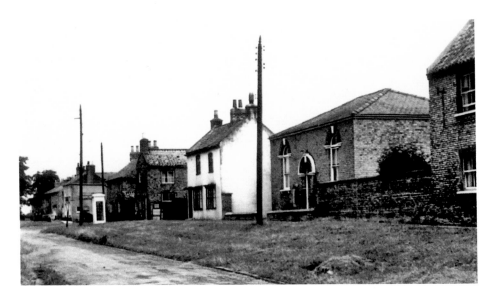

Barmby Moor Methodist Church

In Chapel Street with the Boot & Slipper visible in the distance in Town Top, now St Helen's Square. Barmby's early economic history is equally fascinating: 'Thirty-one villeins [a medieval serf] held 60 bovates [the amount of land an ox could plough in one year], paying £7 10s rent and rendering poultry and eggs at Christmas and Easter, generally at the rate of 2 cocks or hens and 23 eggs to the bovate; they also owed hay-making and hay-carting works, the duty of carting the lord's fuel and timber "within Derwent", and arbitrary relief and merchet (a fine paid on marriage). Twenty-seven cottars held 32 tofts [a homestead], a croft, and 3½ acres for about £1 10s, as well as poultry and eggs, usually giving 23 eggs for each toft. They also owed haymaking service and a day's work at harvest-time, worth 1d, and were bound to work for the lord from Michaelmas to Lammas for 1d a day' (From *A History of the County of York East Riding Volume 3*).

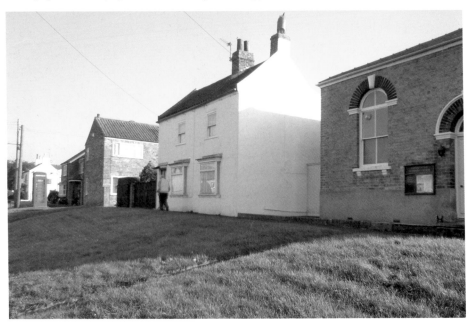

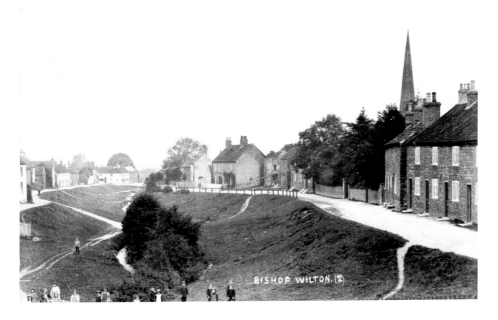

Bishop Wilton and the Archbishop of York's Palace

The 'Bishop' in the village's name derives from the fact that it was once the Archbishop of York's palace, built in around 1220, during the office of Walter de Grey who was Archbishop from 1216 to 1255. Unfortunately, it was not to last long and was in a state of some disrepair by around 1388. Nevertheless, the site of the palace and part of the moat can still be seen in the fields opposite the school. St Edith's church dominates the skyline in both photographs, particularly imposing when seen from the beck valley.

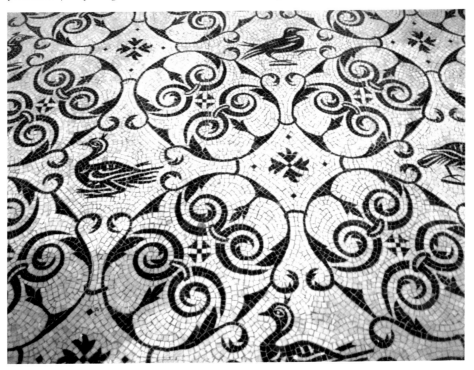

81

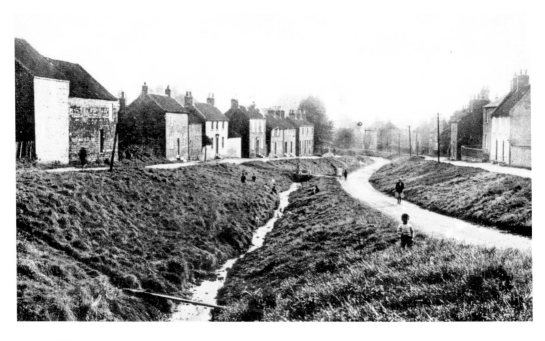

Bishop Wilton
The Fleece Inn is visible in the background before it was rebuilt in the 1920s. Procter's is opposite, later to become the Pocklington & District Co-operative Society.

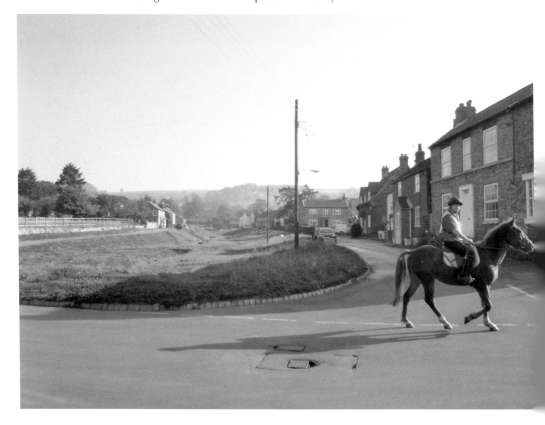

St Edith and the Vatican

St Edith of Wilton Church rises majestically when viewed from the beck 'valley'. Although parts are Norman, much of what we see is due to the restoration carried out by Sir Tatton Sykes in 1859. This includes the superb hammer-beamed roof and the magnificent floor designed by J. L. Pearson and Temple Moor. The floor is based on a design by Salviati copied from a floor in the Vatican, itself inspired by the Palace of the Caesars in Rome. It was delivered by train to Fangfoss station and shipped on to Bishop Wilton by horse and cart. See page 81 for a picture of the floor.

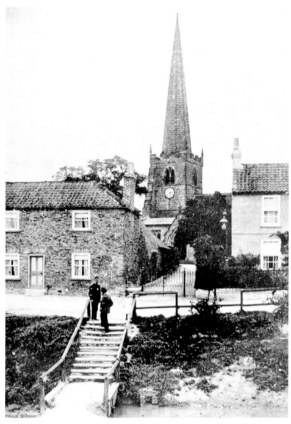

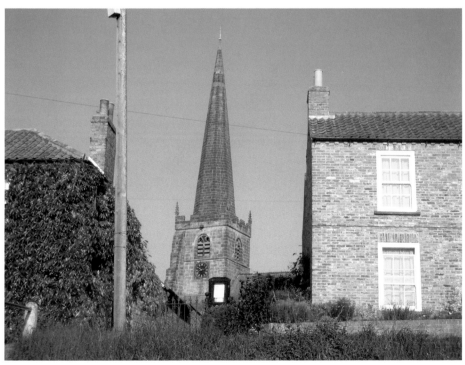

Everingham

Everingham has the unusual distinction of having two churches dedicated to St Everilda, a seventh-century saint who founded a convent in the village: St Everilda's (Church of England) and Ss Mary and Everilda, (Roman Catholic). Moreover, the only other church in Britain dedicated to St Everilda is at Nether Poppleton to the west of York. The new photograph is of the impressive sundial on the front of the old Wesleyan chapel of 1837.

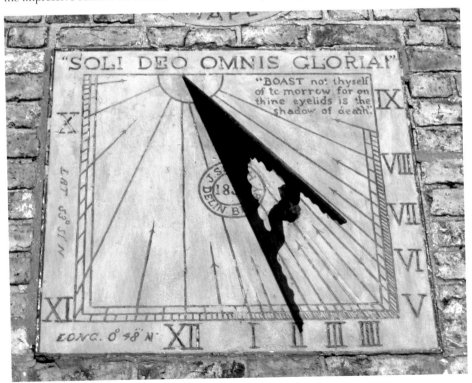

"SOLI DEO OMNIS GLORIA!"

"BOAST not thyself of to-morrow for on thine eyelids is the shadow of death."

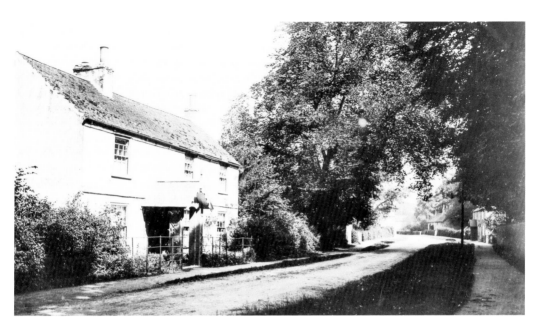

Everingham – Recusant Village

After the Reformation, Everingham was, in effect, a recusant village, and the Italianate-style St Mary & Everilda was built in the grounds of Everingham Hall within a decade of the Catholic Emancipation Act of 1829. It was designed in Italy by Agostino Giorgioli, inspired by the Maison Dieu at Nîmes. Its construction was supervised by John Harper of York. Tragically, the church is on private land with very limited access – a shame on a number of counts, both religious and secular – so the second photograph shows the College Arms instead.

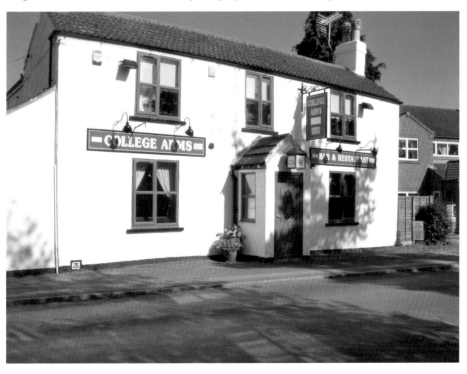

Fangfoss and the Rocking Horses

Called 'Frangefos' in the Domesday Book, the name possibly means the ditch used for fishing, from the Old English *foss* and Scandinavian *fang* for fish. Fangfoss is home to the fascinating Rocking Horse Shop; Anthony Dew and Jane Cook and their team of craftsmen started designing and making wooden rocking horses in 1976. In October 2011 their Bigger Bertie, the world's biggest rocking horse, was the main attraction at the World Skills Competition at London's Excel Centre. It measures over 14 feet high, 5 feet 8 inches wide and more than 28 feet long.

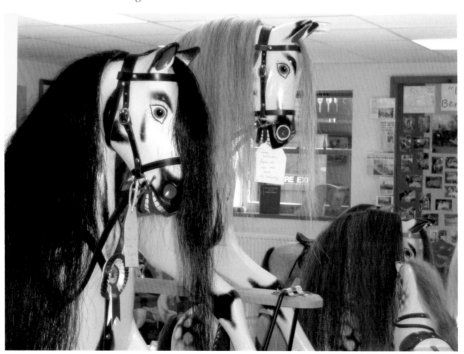

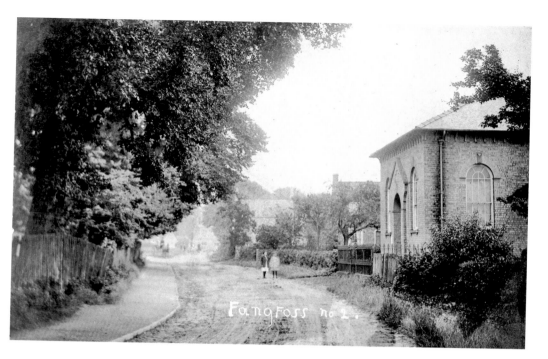

Fangfoss no. 2.

Dissenters

The earliest evidence of dissenting worship here was in 1777, when a house was registered for the purpose. The Methodists had seventeen members in 1787 and up to twenty-three in the period to 1816. A Wesleyan chapel and schoolhouse were built opposite the church in 1837, later to be replaced by the Primitive Methodists' Canaan chapel, which closed in 1974.

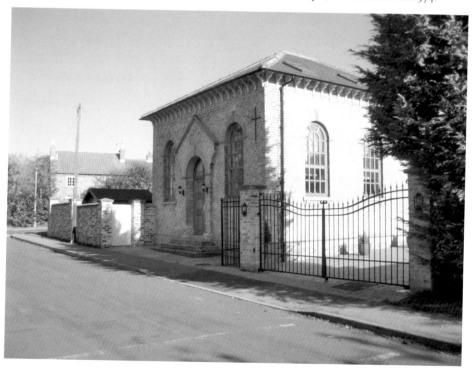

Fangfoss School: 'Enter and Improve'

Mission statement or command? Education began in Fangfoss in 1819 when the parishioners hired a schoolmaster to teach twenty-five or so pupils. In 1835 the Primitive Methodists were running a parent-funded day school. A new National School was built on the site of the old Wesleyan chapel in 1867. Fangfoss Pottery has occupied the old school building since 1977.

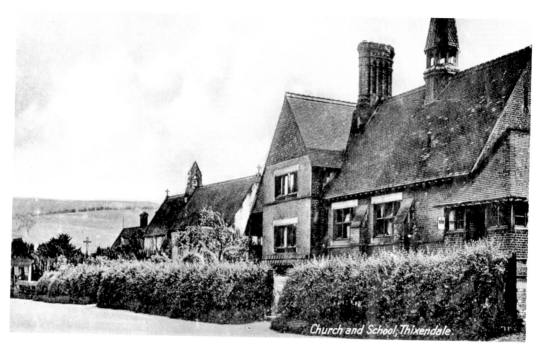

Thixendale Church and School

The original school, between Ash Tree and Cottage farms, opened in 1849. It was superseded in 1876 by the school here. The church, St Mary's, was consecrated in 1871 by the Archbishop of York and financed by Sir Tatton Sykes.

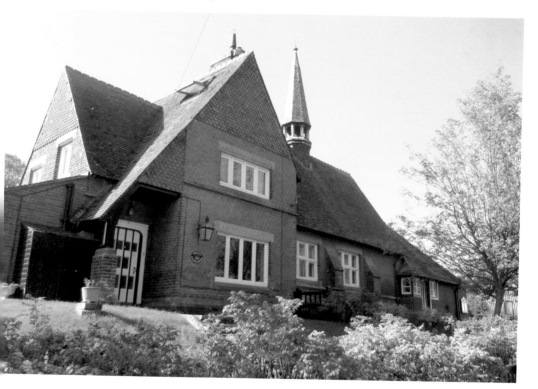

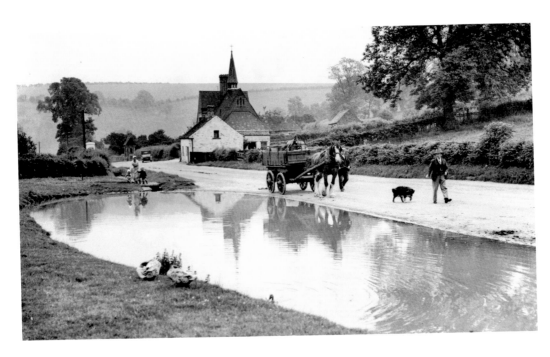

Sixteendale

Domesday has it as Sixtedale, Sixtendale and Xistendale. All mean Sixteen Dales and that is precisely where the village gets its name: from the sixteen dales that converge here. They are: Blubberdale, Broadholmedale, Buckdale, Bowdale, Breckondale, Courtdale, Fairydale, Fotherdale, Honeydale, Longdale, Middledale, Millamdale, Pluckamdale, Warrendale; Waterdale and Williedale.

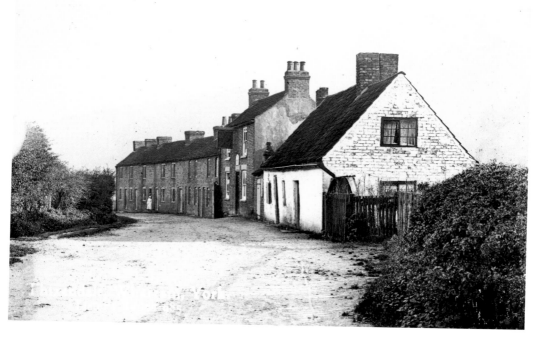

The Cross Keys

Jewison's Terrace, or Teapot Row, consists of eight brick cottages built by Henry Jewison, the churchwarden, next to the Cross Keys. Mr Jewison, who was a farmer at Raisthorpe, built them for his labourers; he was killed during a hunt in 1876. Anne and Harriet Towse ran the Cross Keys until around 1900.

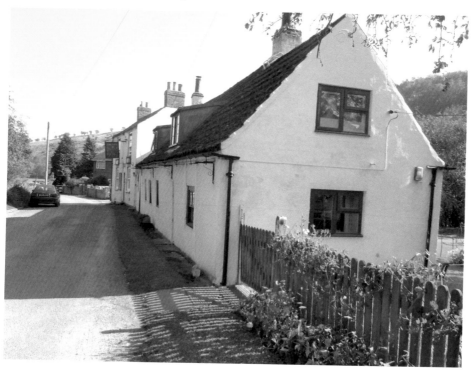

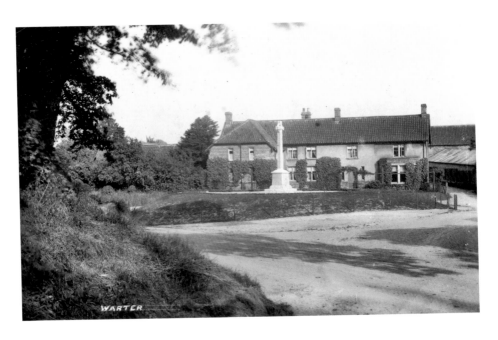

Warter

Warter war memorial, commemorating nine fallen in First World War, with Ludhill House in the background. Nearby was the Augustine Warter Priory, now demolished, which was dedicated to St James and founded in 1132 by Geoffrey Fitz-Pain. Some of the buildings were built by Charles Henry Wilson (1833–1907), owner of Thomas Wilson Sons & Co., at one time the world's largest privately owned shipping company. It was sold to the Ellerman Line in 1916.

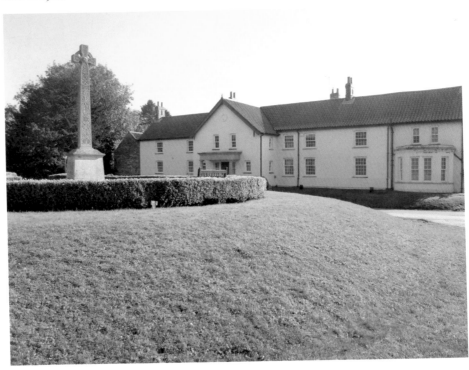

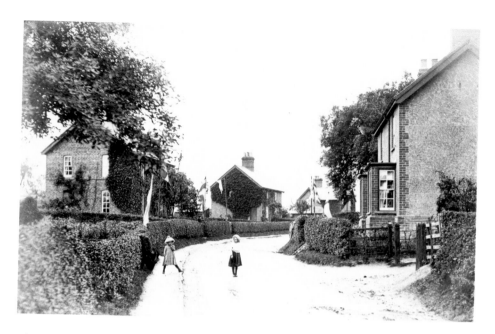

Bigger Trees Near Warter

Or, to give it its alternative title, *Peinture en Plein Air pour l'age Post-Photographique*. David Hockney's largest painting at 15 feet by 40 feet painted between February and March 2007 made this picturesque village world famous. Its subject is a copse of trees bursting into life in spring. The title refers to Hockney's technique: painting outside and in front of the subject (*sur le motif*), incorporating digital photography. In 2008, Hockney donated the work to the Tate Modern.

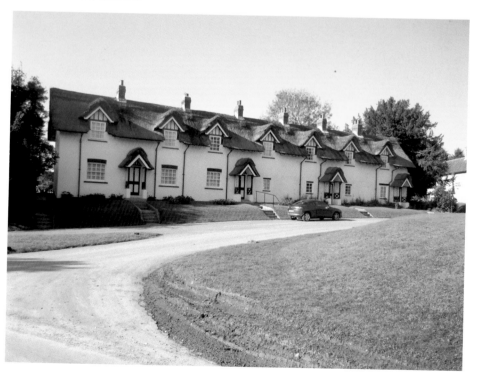

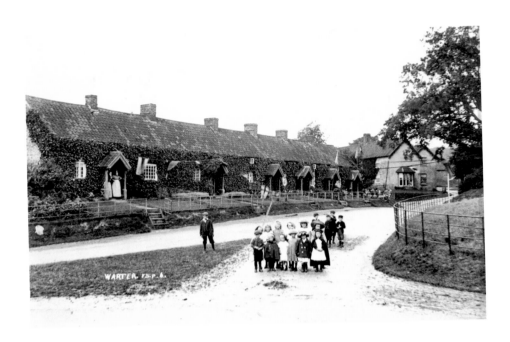

Warter

The attractive, whitewashed thatched cottages on the left of the green here and on page 93, with their gabled windows and latticed porches, are of the nineteenth century, and the village retains its original cast-iron street lights. Pevsner, in his *York and the East Riding* volume says, 'Warter is a curious village, perversely attractive ... a very pretty row of thatched cottages ... for the rest it has fiercely Victorian houses ... always accompanied by bulging topiary'.

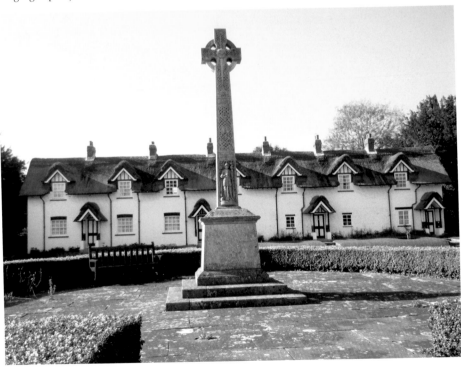

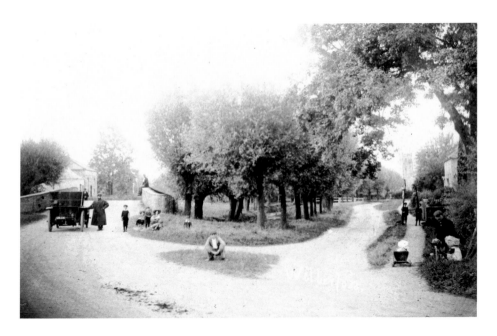

Wilberfoss

The first recorded alehouse here was licensed in 1729, later accompanied by up to four others later in the century. In 1823 there were the Horseshoes or the Blacksmith's Arms (demolished to make way for the bypass), the True Briton, and the Waggon & Horses. The True Briton became the Oddfellows Arms around 1840 and the Waggon & Horses had closed before 1872.

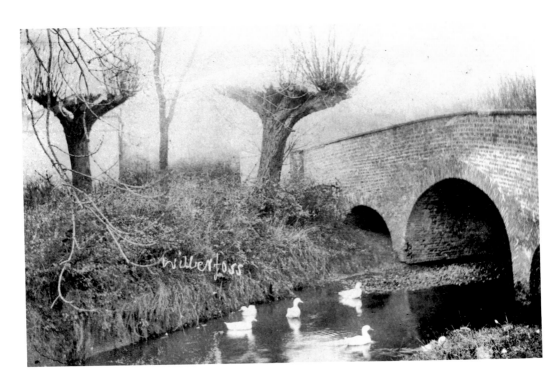

Wilberfoss Bridge
Before the village was bypassed in the 1960s, the main road crossed Foss Beck by Stone Bridge.
Today's eighteenth-century bridge, as here, consists of three brick arches.

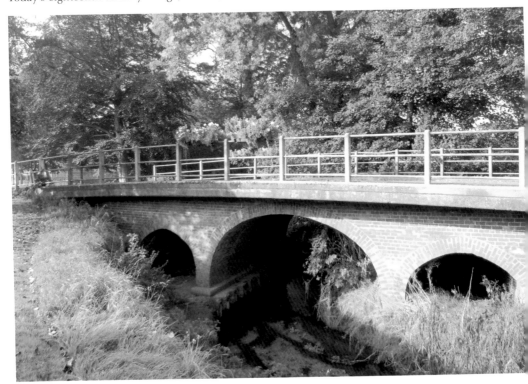